IMAGES
of America

COLUMBUS ITALIANS

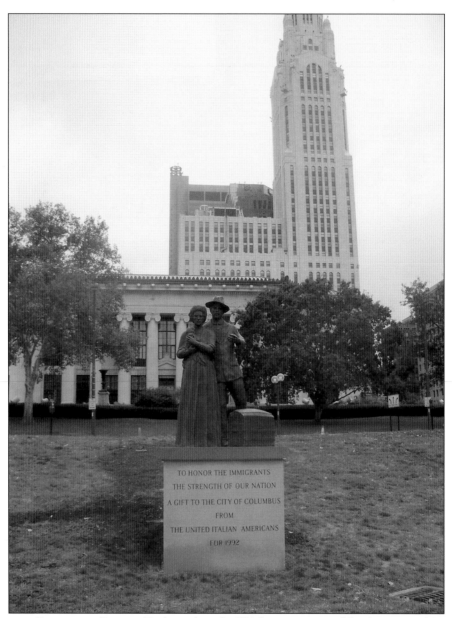

COLUMBUS IMMIGRANT STATUE. Dedicated on the 500th anniversary of the discovery of America by Christopher Columbus, this statue stands at Battelle Riverfront Park along the banks of the Scioto River in downtown Columbus. It honors the many Italian families who fled their homeland in search of a better life in Central Ohio during the late 19th and early 20th centuries. (Courtesy of Dominianni family.)

ON THE COVER: In 1915, Paolo and Louisa DiPaolo opened DiPaolo Food Shoppe on St. Clair Avenue in the heart of one of Columbus's most vibrant Italian neighborhoods. With the help of their son Richard, the small immigrant grocery store would eventually become a $75-million food distribution empire. Pictured are, from left to right, Mary Lou Casanta, Frankie Casanta, Paolo DiPaolo, Louise DiPaolo, Rose Crognel, Rita DiPaolo, and Richard "Richie" DiPaolo. (Courtesy of Paul DiPaolo.)

IMAGES
of America

COLUMBUS ITALIANS

Andy Dominianni and Erin Dominianni

ARCADIA
PUBLISHING

Published by Arcadia Publishing
Charleston, South Carolina

Printed in the United States of America

Library of Congress Control Number: 2010942685

For all general information, please contact Arcadia Publishing:
Telephone 843-853-2070
Fax 843-853-0044
E-mail sales@arcadiapublishing.com
For customer service and orders:
Toll-Free 1-888-313-2665

Visit us on the Internet at www.arcadiapublishing.com

*To our children, Riley Eileen and William Giusto, who
have inspired us beyond measure; that they may always
celebrate who they are and where they came from.*

CONTENTS

ACKNOWLEDGMENTS

Within these pages are the stories of hundreds of Columbus Italian families who share similar, yet often vastly different, immigration experiences. Most of the research materials and photographs compiled for this book came not from libraries or historical archives but from the attics, family albums, and quite literally off the walls of Italian immigrants and their descendants. We came to know these families. We sat around their dinner tables. We went to their reunions. We heard their stories, recounting successes and setbacks, celebrations and sorrows. We learned far more than can be included here. *Columbus Italians* represents just a few chapters of a much longer tale.

We owe a special debt of gratitude to the wonderful people and loving community of St. John the Baptist Italian Catholic Church, who have welcomed us with open arms and made us feel like family. The importance of faith, family, and friends in their lives has inspired us to write this book.

A special thanks to our dear friends the Auddinos and the Codispotis for adopting us as their own.

INTRODUCTION

For three days each fall, Italian Village in downtown Columbus looks, sounds, and smells like the immigrant neighborhoods of 100 years ago. Just as the cool evening breeze breaks the fever of the hot, Indian-summer October days, the place comes alive with color, music, and festivity. The smell of homemade sauce and the frantic rhythms of La Tarantella permeate the night air. As large crowds converge on the makeshift town square, you can hear loud expressions of affection all around. The Columbus Italian Festival is, after all, at its heart a family reunion. Italian American families in Columbus are forever bonded by the festival's longtime mantra, "faith, family, friends," by the new city they now call home, and by the old country that will forever be home in their hearts.

In 1900, there were more than 11,000 Italians living in Ohio. By 1920, that number had soared to more than 60,000. Most of these Italians settled along Lake Erie, near Cleveland, but a growing number started migrating south to the state capital of Columbus at the confluence of the Scioto and Olentangy Rivers. Columbus Italian families stayed close to each other, living in large concentrations on St. Clair Avenue, along Goodale Street in the melting-pot neighborhood that came to be known as Flytown due to the large number of shanty homes that "flew up" here during the first part of the 19th century, and also in the communities of Grandview Heights, the Bottoms, Marble Cliff, and San Margherita. In these tight-knit communities could be found a mix of small businesses, including bakeries, grocery stores, and taverns.

The men found work as day laborers or at factories within walking distance of their homes at places like Jeffrey Coal Mining Equipment Manufacturing Company, Smith Brothers Hardware Company, the Twentieth Street Rail Yard, and the Marble Cliff Quarry. With their paychecks, they frequented Italian-owned businesses, like Santilli's Pool Hall, Amicon Produce, Carfagna's Deli, Melchiorre's Grill, and Presutti's Villa, where they would assuredly find a friendly face, a common language, and the highest quality of food products in town.

Today, Columbus Italians still stick together; however, they no longer require the moral support earliest immigrants did. Italian culture in Central Ohio is now, simply, something to celebrate.

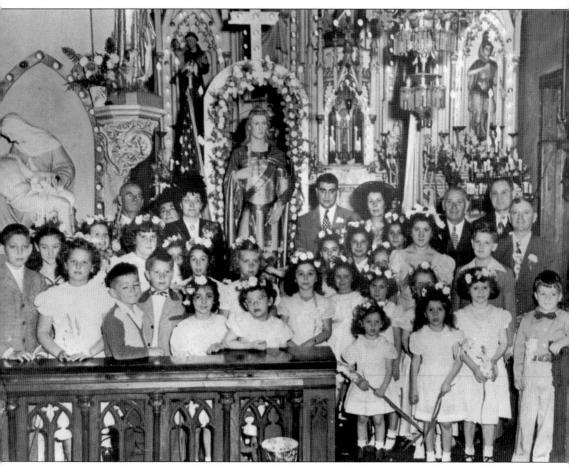

FEAST OF ST. PROSPERO, 1949. The Feast of St. Prospero is held on the first Sunday of September, in honor of the patron saint of Faeto, Italy, in the province of Foggia, Apulia. In 1949, the Faetani in Columbus raised enough money for a statute of St. Prospero to be made and shipped from Italy to St. John the Baptist Italian Catholic Church in Columbus, where it remains on display. Pictured here are parish children with several benefactors, including Grace Martina (in the large hat) and John Quint (in the glasses at far right). (Courtesy of St. John the Baptist Italian Catholic Church.)

One

FAITH

In 1896, Columbus bishop John A. Watterson, recognizing the need for Italians in the city to have a place of worship of their own, created an Italian national parish and invited recent transplant Fr. Alexander Cestelli to lead them. For two years, the small congregation assembled for mass each Sunday morning in the baptistery of St. Joseph Cathedral. Finally, after raising enough money to build their own church on four plots of land at the corner of Lincoln and Hamlet Streets, St. John the Baptist Italian Catholic Church was born. St. John's was, and still is, the epicenter of Italian life in Columbus and, in more recent years, has expanded to include an Italian Cultural Center and the popular Columbus Italian Festival. In 1920, there were some 550 Italian national parishes in the United States. Now, almost a century later, urban development and suburban sprawl have claimed most of them. St. John the Baptist Italian Catholic Church, where portions of mass are still said in Italian, is one of the few that remains.

Due to the lack of public transportation at the beginning of the 20th century, St. John's, situated just north of downtown Columbus, was not easy to get to for some of the Italian immigrants who had settled near the stone quarry west of town. For this reason, in 1921, a group of families in the San Margherita neighborhood pooled their resources to build their own parish, to be named after the patron saint of Pettorano, Cassett', Santa Margherita de Cortona. The first mass at St. Margaret of Cortona Church took place on August 23, 1922.

Still some other Italians chose to worship at the parish closest to them, including St. Francis of Assisi in the Flytown neighborhood, Our Lady of Victory Church in Grandview Heights, and St. Peter's Catholic Church in the Milo neighborhood.

Regardless of where they attended mass on Sundays, for Italian immigrant families, their unwavering faith in God gave them the strength to overcome many obstacles and succeed in their new lives in the United States.

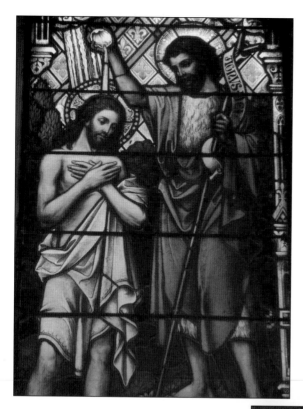

St. Joseph Cathedral Baptistery. In the late 1800s, before they had a church of their own, the Italian immigrants of Columbus would assemble for mass on Sunday mornings at 9:00 a.m. in the baptistery of St. Joseph Cathedral under this stained glass image of St. John the Baptist. In 1898, they founded a new parish whose name was inspired by the saint who oversaw their earliest gatherings. (Courtesy of Dominianni family.)

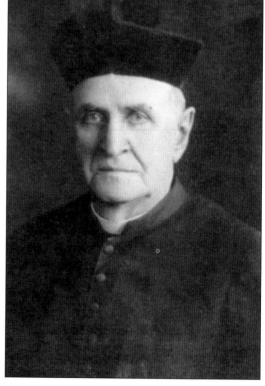

Fr. Alexander Cestelli. The first pastor of St. John the Baptist Italian Catholic Church, Fr. Alexander Cestelli, was born in Borgo Sansepolcro, Italy, in the province of Arezzo, Tuscany, on September 26, 1840. He came to the United States at the invitation of Archbishop John Ireland of St. Paul, Minnesota, to join the faculty of St. Thomas Seminary in St. Paul and later, at the request of Msgr. Joseph Jessing, became a professor of moral theology at the Pontifical Josephinum College in Columbus. In October 1896, with the blessing of Bishop John Ambrose Watterson, Father Cestelli founded the parish of St. John the Baptist Italian Catholic Church and undertook the spiritual guidance of the Italian immigrants in Columbus. In 1901, Father Cestelli became the pastor of St. Michael's Italian Church in Portland, Oregon. He was killed three days before Christmas in 1916 in a streetcar accident at the age of 76. (Courtesy of St. John the Baptist Italian Catholic Church.)

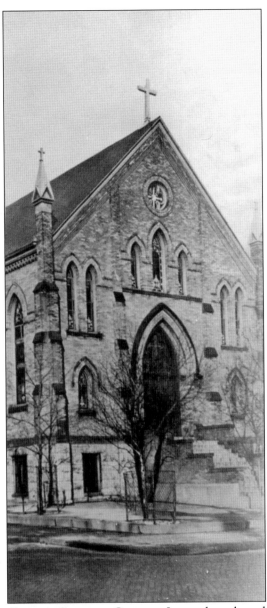

St. John the Baptist Italian Catholic Church. Located on the cobblestoned intersection of Lincoln and Hamlet Streets in the neighborhood now called Italian Village, St. John the Baptist Italian Catholic Church has been the heart of the Columbus Italian community since the cornerstone was laid on May 15, 1898, with a subsequent official dedication the following September. Fr. Alexander Cestelli had purchased four building lots at a cost of $4,700 in late 1897, and plans were put in place to build the church. A large donation from John Marzetti, along with a parish raffle, secured the necessary funds to begin construction. The building was designed to be Gothic in style by architect D. Riebel, with a steeple and spire 98 feet tall. The exterior was yellow brick, and the church was built to hold 480 people. St. John the Baptist Italian Catholic Church has recently been restored to its original grandeur and remains an Italian national parish—the most popular place for Italian weddings and social events and the centerpiece of the annual Columbus Italian Festival. (Courtesy of St. John the Baptist Italian Catholic Church.)

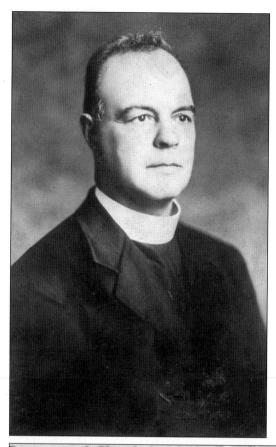

FR. ROCCO PETRARCA. Born in Bordighera, Italy, in the province of Imperia, Liguria, on July 24, 1877, Fr. Rocco Petrarca came to Columbus by way of Pennsylvania, becoming the third pastor of St. John the Baptist Italian Catholic Church in 1913. In addition to being a much beloved priest, Father Petrarca was also an experienced physician, a talented musician, and a prolific inventor, creating, among other things, one of the first electric garage door openers. A bronze bust of Father Petrarca was dedicated on July 27, 1975, and stands outside St. John the Baptist Italian Catholic Church, over which he presided for 35 years. (Both, courtesy of Asmo/Jaconetti families.)

Basement of Church Is Mechanical and Electric Workshop for Priest,
Fr. Petrarca of St. John's the Baptist Also Studied Music, Medicine

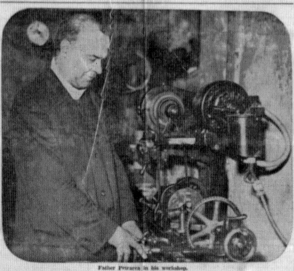

Devises Clock in His Vestry Room to Ring Bell In Tower.

By EARL MENDERMAN.

Also Has Gadget Which Changes Alternating To Direct Current.

NARARIO PALMA AND MARIA MORMILE WEDDING, MAY 20, 1920. The wedding of Narario Palma and Maria Mormile was held at St. John the Baptist Italian Catholic Church. Narario was a native of Foggia, Italy, and a World War I veteran. Maria was the oldest of 11 children born to Italian immigrants Antonio and Annunziata Mormile. Narario and Maria lived in Grandview Heights and had five children. (Courtesy of George Bleimes.)

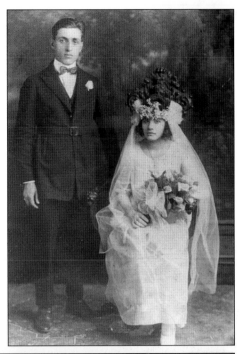

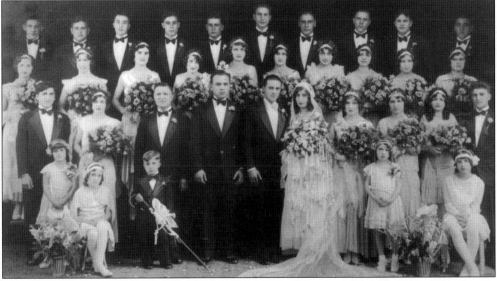

GAETANO "GUY" FRACASSO AND MARY GRACE GIAMARCO WEDDING, SEPTEMBER 10, 1930. Friends and family of Gaetano Fracasso and Mary Grace Giamarco are pictured with the couple on their wedding day in 1930. Those pictured are, from left to right, (first row) Mary Fracasso, Jean DelCol, Louis Giamarco Jr., Lillian Santilli, and Lillian Billi; (second row) Menotti "Peanuts" Fracasso, Ida De Santos, Louis Giamarco Sr., Henry De Santis, Gaetano "Guy" Fracasso (groom), Mary Grace Giamarco (bride), Lena Giamarco, Jean Santilli, Frances Arcudi, and Henry Giamarco; (third row) Clair Tiberi, Alda Volpe, Carmella Calderella, Viola Verne, Theresa Susi, Josephine Giuffre, Lizzie Winks, Yola DeCinzo, Rose Salini, and Josephine Melchiorre; (fourth row) Guido Fontanarosa, Marion "Tubby" Melchiorre, Al Cacchione, Julian "Sword" Verne, Lucian Susi, Peter Volpe, Joe Winke, Al Ventresca, Tony Susi, and Dominic Melchiorre. (Courtesy of George Bleimes.)

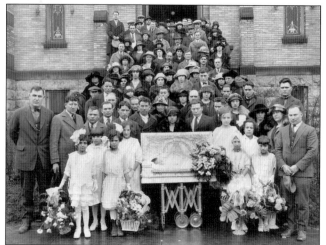

PANFILO DI PIETRO FUNERAL, MARCH 1924. Vincezo and Crucifissa (D'Amico) Di Pietro lost their second child at the age of six months to pneumonia. Panfilo's funeral was held at St. John the Baptist Italian Catholic Church. Both Vincent and Crucifissa immigrated to Columbus from Abruzzo. They lived on Harrison Avenue in the Flytown neighborhood and had eight children. (Courtesy of Gloria Di Pietro.)

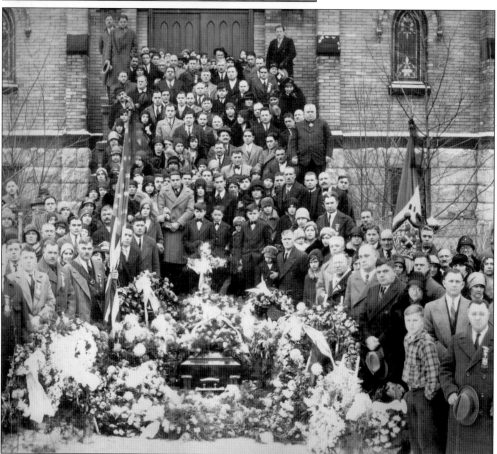

FUNERAL AT ST. JOHN THE BAPTIST, 1929. The funeral of Giuseppe Fracasso was held at St. John the Baptist Italian Catholic Church. Fracasso, a well-known shopkeeper, died after two years of heart problems. Included in the large crowd were men wearing SFI ribbons, representing Societa Fratellanza D'Introdacqua, a fraternal organization that Fracasso helped found in 1915. The group exists to this day. (Courtesy of Nick Colasante.)

FRANK CASANTA AND MARY PASQUA DIPAOLO WEDDING, APRIL 25, 1935. Frank Casanta, the youngest child of Marianna and Angelo Casanta, married Mary Pasqua DiPaolo, the oldest daughter of Paolo and Louisa DiPaolo, at St. John the Baptist Italian Catholic Church in 1935. They were married on a Thursday, because that was the one day that Paolo DiPaolo closed his grocery store. Their reception featured the Cincione brothers' bands. The couple had three children and lived in the Milo neighborhood. (Courtesy of Casanta family.)

JOHN BOLOGNONE AND FILOMENA "MINNIE" PALMA WEDDING, SEPTEMBER 5, 1936. John Bolognone and Filomena "Minnie" Palma were married at St. John the Baptist Italian Catholic Church by Fr. Rocco Petrarca in 1936. The children of Italian immigrants, John and Minnie were born, by pure coincidence, in the same house at 1015 John Street in 1909 and 1913 respectively. The couple had five children, three girls and two boys. (Courtesy of Bolognone family.)

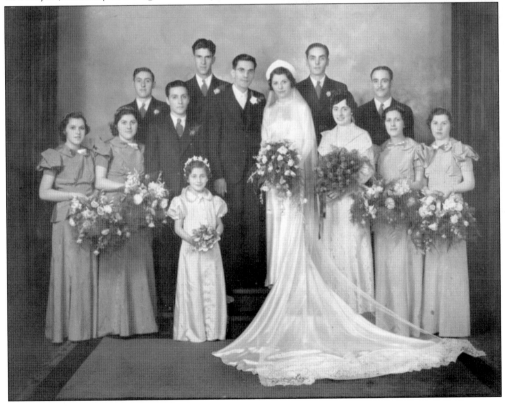

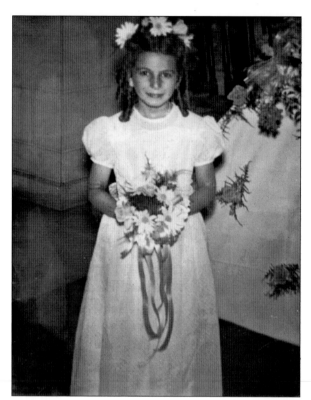

MAY CROWNING, C. 1947. Seven-year-old Noreen De Santis is pictured here before the May Crowning Procession honoring the Blessed Mother at St. John the Baptist Italian Catholic Church. Young girls in the parish wore white gowns and brought flowers to the May altar. Noreen was one of Pasquale and Vienna De Santis's four children. Pasquale came from Abruzzo with his brothers in the 1920s and started a landscape and greenhouse business. The business grew into De Santis Florists, Inc., which is still in operation. Notice the fresh flowers in Noreen's hair. (Courtesy of Noreen De Santis Drake.)

SENIOR HOLY NAME SOCIETY. During his 35-year tenure as pastor of St. John the Baptist Italian Catholic Church, Fr. Rocco Petrarca organized six basic societies, Senior Holy Name, Junior Holy Name, Holy Rosary, Immaculate Conception, Holy Angels, and Adolorata Society. Father Petrarca stressed to his parishioners the importance of these civic groups in growing and maintaining the church. Pictured here is an annual dues booklet belonging to a member of the adult male group, the Holy Name Society. (Courtesy of St. John the Baptist Italian Catholic Church.)

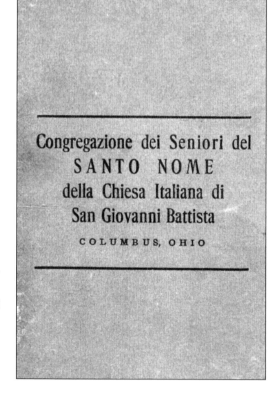

Congregazione dei Seniori del
SANTO NOME
della Chiesa Italiana di
San Giovanni Battista
COLUMBUS, OHIO

Samuel James Gugliemotto and Amelia "Nellie" Mormile Wedding, August 15, 1946. Samuel James Gugliemotto, a World War II Marine Corps veteran, married Nellie Mormile at St. John the Baptist Italian Catholic Church in 1946. Samuel worked in concrete and roofing until lung problems forced him to retire. Nellie was employed by the Columbus Defense Depot. The couple had two children. (Courtesy of George Bleimes.)

Charles Agriesti and Bonnie West Wedding, October 7, 1961. Charles Agriesti and Bonnie West were married in 1961 at St. John the Baptist Italian Catholic Church. The wedding lunch followed at Presutti's Villa in Grandview Heights with an evening reception at the American Italian Club on Wilson Road. Charles owned Agriesti's Grill on North High Street with his father and brother for many years. Charles and Bonnie had two daughters and are still active members of St. John the Baptist Italian Catholic Church. (Courtesy of Agriesti family.)

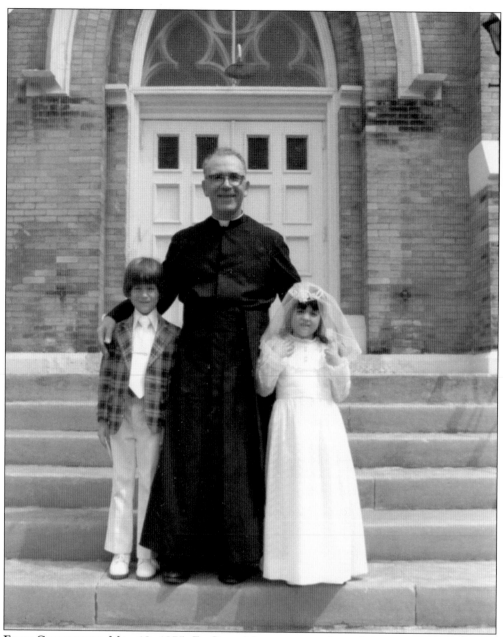

FIRST COMMUNION, MAY 18, 1975. Fr. Casto Marrapese was the eighth pastor of St. John the Baptist Italian Catholic Church from 1974 until 1991 and was the last to serve the church from the Pontifical Institute for Foreign Missions (PIME). Born in Calvi Risorta, Italy, in the province of Caserta, Campania, Father Marrapese studied theology at the Angelicum University in Rome and taught literature and dogmatic theology in a PIME Seminary. He founded the Columbus Italian Festival in 1980, founded the Fr. Casto Marrapese Scholarship Fund, and raised the money for and built the Italian Cultural Center adjacent to the church. Upon his retirement, Father Marrapese moved to the PIME Mission Center in Newark, Ohio. He is pictured here on the steps outside St. John the Baptist Italian Catholic Church, celebrating the First Holy Communion of Anthony Militello and Ida Tiberi in 1975. (Courtesy of Rena Tiberi.)

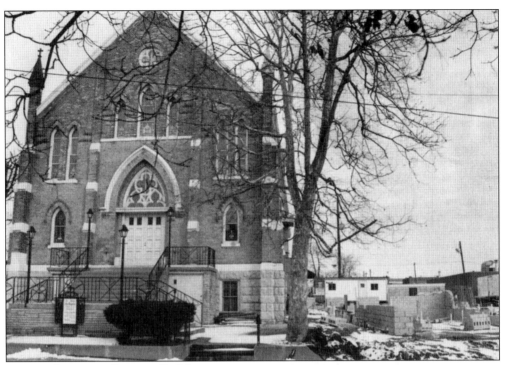

ITALIAN CULTURAL CENTER. St. John the Baptist Italian Catholic Church had stood proudly as the focal point of the Columbus Italian community for almost a century when, in 1974, Fr. Casto Marrapese began dreaming of building the Italian Cultural Center that would serve the community as a place to learn about their heritage. After razing the Dominican Sisters of the Sick Poor's convent next door and an exhaustive capital campaign that would last 15 years, the center was finally built and dedicated on October 29, 1989. In his message to the congregation, Father Marrapese dedicated the building to the memory of "the Italian immigrants who, with their faith, their strong family ties, and hard work, paved the way for us and contributed so much to the progress of Central Ohio." (Both, courtesy of St. John the Baptist Italian Catholic Church.)

Photo of St. John the Baptist Church and The Italian Cultural Center

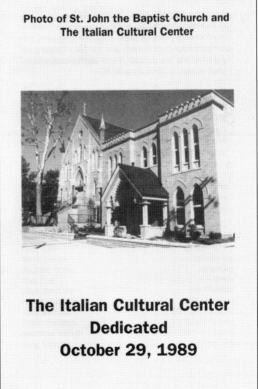

The Italian Cultural Center Dedicated October 29, 1989

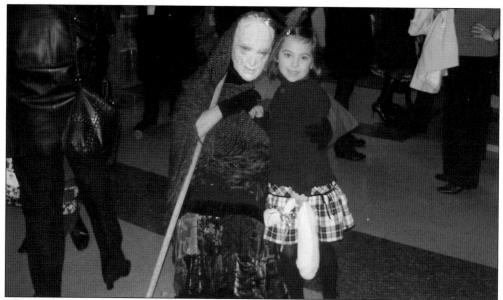

LA BEFANA. According to folklore, La Befana, a woman forever in search of the baby Jesus, arrives on a broomstick and visits the children of Italy on the eve of the Feast of the Epiphany, filling the socks of well-behaved boys and girls with presents. Being a good housekeeper, many say she sweeps the floor before she leaves. Bianca Milano, the longtime La Befana at St. John the Baptist Italian Catholic Church, is pictured here in costume with Riley Dominianni in 2008. (Courtesy of Dominianni family.)

SALA HALL. Named after Fr. Charles Sala, the sixth pastor of St. John the Baptist Italian Catholic Church from 1949 to 1956 and again from 1957 to 1961, Sala Hall is located in the under croft of the church and serves as a meeting place for the congregation. Clara Zari, a longtime parishioner, enjoys the after-mass tradition of coffee and donuts in Sala Hall. (Courtesy of Larry Pishitelli.)

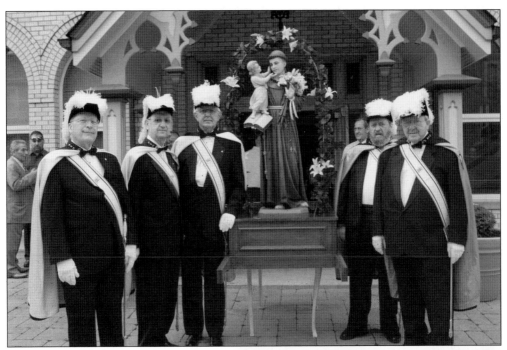

FEAST OF ST. ANTHONY. Canonized by Pope Gregory IX within a year of his death in 1232, St. Anthony of Padua is one of the most beloved saints in the Italian culture. The annual Feast of St. Anthony at St. John the Baptist Italian Catholic Church includes a procession of his statue by the Knights of Columbus and the distribution of St. Anthony's bread, representing a promise to help the poor in return for his intercession. (Courtesy of Larry Pishitelli.)

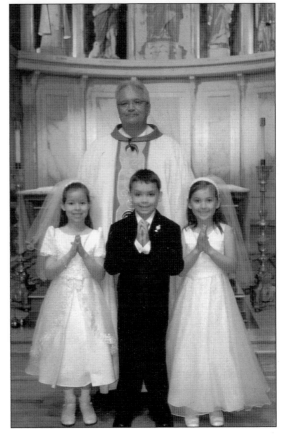

FIRST COMMUNION AT ST. JOHN THE BAPTIST ITALIAN CATHOLIC CHURCH. Fr. William A. Metzger became the 10th pastor of St. John the Baptist Italian Catholic Church in 1998. Under his leadership, the church was restored to its original grandeur, and the Columbus Italian Festival was returned to the church grounds. Father Metzger celebrates the First Holy Communion of three communicants, May 2, 2010. Pictured are, from left to right, Chiara Maria Masdea Baker, Gabriel Bishop, and Riley Dominianni. (Courtesy of Margi Masdea Baker.)

ORIGINAL ST. MARGARET OF CORTONA CHURCH. In 1909, the families who lived in San Margherita petitioned diocesan authorities for their own church. These efforts were renewed in 1921, and construction soon began at 3388 Trabue Road, with 13 families, DiVittorio, Ciconi, Castorano, Delewese, Lancia, Oddi, Scarpitti, Moro, Bellisari, Valerio, Stachiotti, Lombardi, and Stischok, each pledging $50. The cinder block and wood-framed church was completed in 1922 and named in honor of Santa Margherita de Cortona, the patron saint of Pettorano, Casett'. (Courtesy of St. Margaret of Cortona Church.)

HELEN D'IPPOLITO'S FIRST COMMUNION, c. 1933. Helen D'Ippolito (second from right) stands with, from left to right, younger siblings Mary, Linda, and Joseph on the occasion of her First Holy Communion at St. Margaret of Cortona Church. Their father, Giuseppe D'Ippolito, was born on March 19, 1895, in Sessano del Molise, Italy, in the province of Isernia, Molise, and came to the United States at the age of 16. Giuseppe soon went back to Italy to marry Assunta Sciarra, and together, they returned to the United States in 1920. (Courtesy of Lisa D'Ippolito McIsaac.)

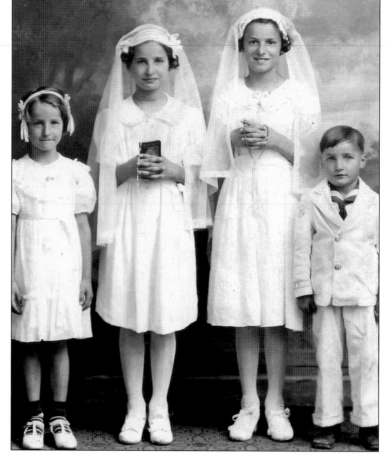

St. Margaret of Cortona Church Procession of Saints, August 2, 1949. Beginning in 1930, the annual St. Margaret of Cortona Church festival concluded with a Sunday morning procession of saints, which continues to this day. In the early years, on the morning of the procession, a band would travel from house to house taking donations and ensuring that all parishioners were awake. (Courtesy of Lancia/Shaffer families.)

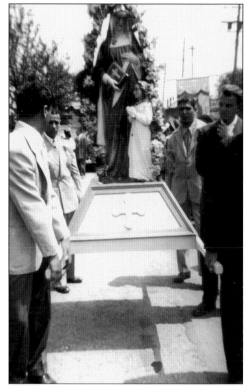

John Shaffer and Durna Lancia Wedding, August 4, 1951. Durna Lancia married John W. Shaffer, a German from the south end of Columbus, at St. Margaret of Cortona Church after the two met on a blind date. The couple had one son but raised Durna's niece from infancy after her mother's death. (Courtesy of Lancia/Shaffer families.)

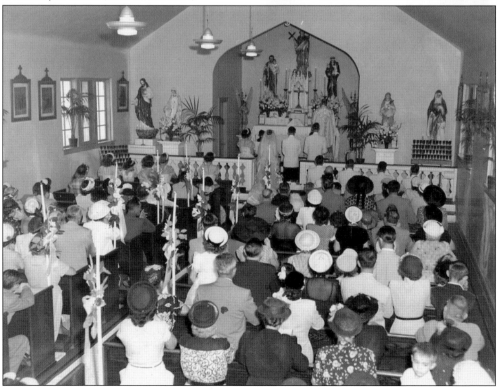

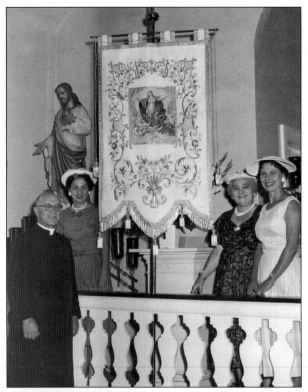

BAPTISM OF THE SOLIDARITY BANNER, 1959. Fr. Ambrose Metzger, the pastor of St. Margaret of Cortona Church, stands with parishioners on the occasion of the Baptism of the Solidarity Banner. Pictured at left are, from left to right, Esther Melaragno, Margherita Dallas, and Durna Lancia Shaffer. The women were part of a social club at the church. Taken in front of St. Margaret of Cortona Church, the photograph below shows the dedication of the Solidarity Banner, which was handcrafted in Italy. The banner was donated to the parish by the Shaffer and Melarango families and remains on display. (Left, courtesy of Lancia/Shaffer families; below, courtesy of Dallas/D'Alessio family.)

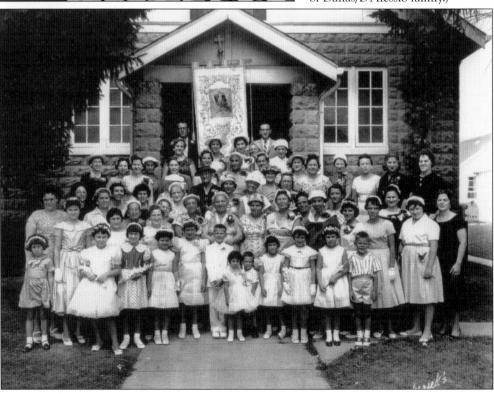

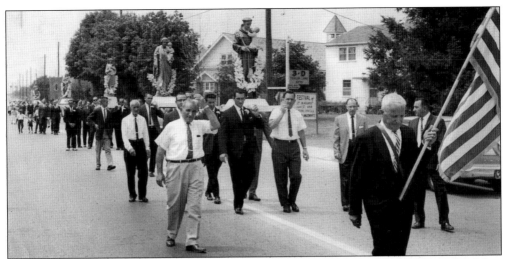

St. Margaret of Cortona Church Procession of Saints, August 2, 1964. The St. Margaret of Cortona Church procession of saints eventually added the patron saints of other Italian villages whose descendants had settled in San Margherita. Starting at the old church and proceeding down Trabue Road, Hague Avenue, and McKinley Avenue, parishioners would bid to carry the patron saint of their hometown and pin money on their clothing as a donation to the church. (Courtesy of St. Margaret of Cortona Church.)

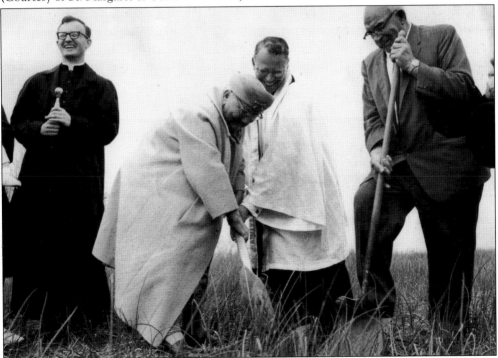

Ground-Breaking for the New St. Margaret of Cortona Church, April 25, 1967. Due to a growing congregation, a larger church became necessary to accommodate the parishioners of St. Margaret of Cortona Church. The two oldest parishioners, Contetina Lancia and Pasquale "Patsy" Ferrelli, were invited to turn the shovels at the ground-breaking with Fr. James W. Kulp in 1967. (Courtesy of St. Margaret of Cortona Church.)

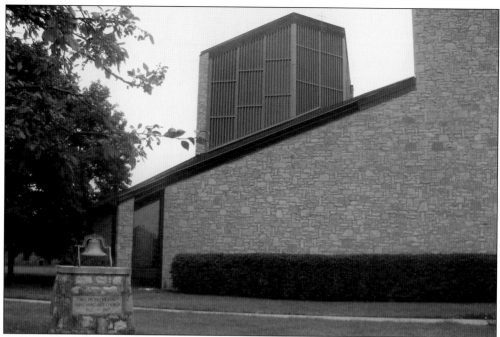

NEW ST. MARGARET OF CORTONA CHURCH. Located at 1600 Hague Avenue, the new St. Margaret of Cortona Church was dedicated on October 20, 1968, by Bishop Clarence E. Elwell. The diamond-shaped church was constructed using rough-hewn limestone rock from the nearby quarry. The original church bell, mounted on a stone pillar, is displayed in front of the new church. (Courtesy of Dominianni family.)

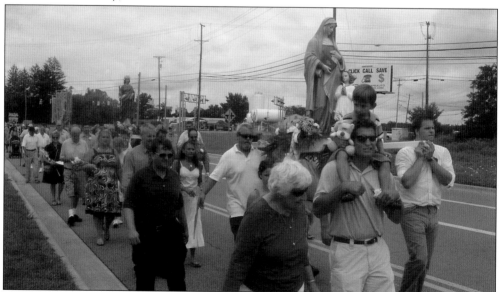

ST. MARGARET OF CORTONA PROCESSION OF SAINTS, AUGUST 1, 2010. Held at the conclusion of St. Margaret of Cortona Church's annual summer festival, on a day designated as "Festival Sunday," the procession of saints continues today as a public expression of faith. Parishioners, representing several generations, still carry the patron saints of their family's region of Italy while singing and praying. (Courtesy of Dominianni family.)

First Communion at St. Francis of Assisi Church, 1920. Many Italian immigrants in the Flytown neighborhood attended mass at St. Francis of Assisi Church. Located at 386 Buttles Avenue, the parish was established by Bishop John Ambrose Watterson on May 24, 1892, and the cornerstone for the Italian Romanesque Revival–style building was laid on September 1, 1895. The founding pastor was Fr. Alphonse M. Leyden. Pictured are, from left to right, Adam Petrella, Berardino Petrella, and Lucia Petrella. (Courtesy of Pat Nance Brown.)

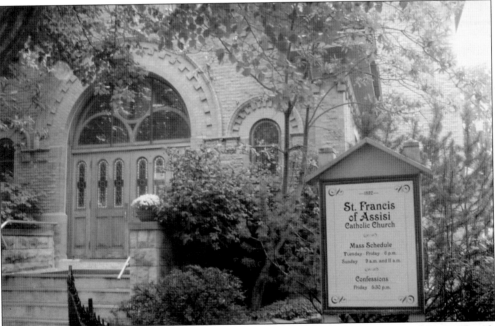

St. Francis of Assisi Church. In 1907, a school opened adjacent to St. Francis of Assisi Church and was staffed by seven nuns of the Dominican Sisters of St. Mary of the Springs. After many prosperous decades, the church encountered a series of setbacks. Much of the surrounding Flytown neighborhood was razed in the late 1950s in the name of urban renewal, driving away a large percentage of the congregation. The school burned to the ground on December 8, 1973. Despite those challenges, St. Francis of Assisi continues to thrive with an active congregation, and the church, social hall, and rectory were all recently renovated. (Courtesy of Dominianni family.)

CARLO VENTRESCA AND MONICA DAMATO WEDDING, OCTOBER 14, 1950. Carlo Ventresca and Monica Damato were married at St. Peter's Catholic Church in the Milo neighborhood in 1950. They held their wedding luncheon at Presutti's Villa in Grandview Heights. They had one daughter, Carol. Carlo worked, along with many other Italians, at Jeffrey Manufacturing Company, a major military contractor that produced, among other things, the chains used to hoist ammunition onto US Naval destroyers. (Courtesy of Carol Ventresca.)

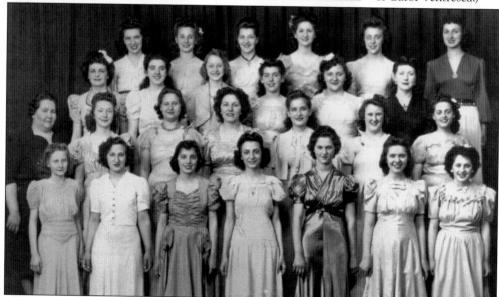

ST. PETER'S CATHOLIC CHURCH GIRLS' CHOIR. Established in 1895 on New York Avenue at Fifth Avenue in the Milo neighborhood of Columbus, near the Italian enclave of St. Clair Avenue, St. Peter's Church was the territorial parish for Italians in that area who could not travel the two miles for mass at St. John the Baptist Italian Catholic Church. St. Peter's had a large and ethnically diverse congregation and a well-known girls' choir before it was razed in the 1960s to make room for Interstate 71. (Courtesy of Edmund D'Andrea.)

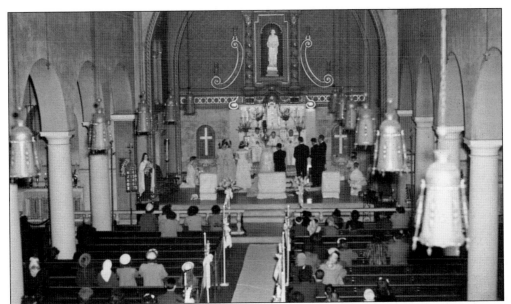

FELICIANO GIAMMARCO AND DILIA VENTRESCA WEDDING, APRIL 30, 1949. Feliciano Giammarco and Dilia Ventresca were married at St. Peter's Catholic Church on New York Avenue in 1949. Both Felix and Dilia emigrated from Introdacqua, Italy, in the province of Aquila, Abruzzo, Felix in 1933 and Dilia in 1947. They did not know each other in Introdacqua, although their families were acquainted. They had three children, Nina, Pasquale, and Laura. This photograph offers a rare glimpse inside the now-demolished St. Peter's Catholic Church. (Courtesy of Cua family.)

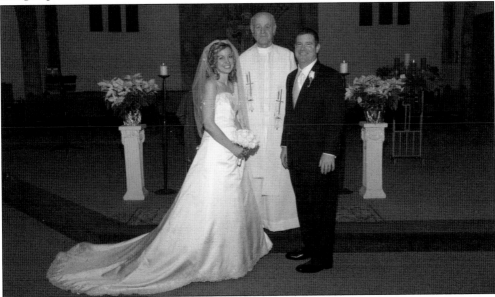

MSGR. ROMANO CIOTOLA. The sixth pastor of Our Lady of Victory Church, Msgr. Romano Ciotola, emigrated with his mother and younger siblings in 1958 to join his father and older sisters, who had already settled in Columbus. He was ordained in 1965 and has served as pastor at a number of Central Ohio churches. Pope John Paul II named him monsignor in 1992. Monsignor Ciotola is shown here with Michael and Maria Albanese on their wedding day in 2008. (Courtesy of Michael Albanese.)

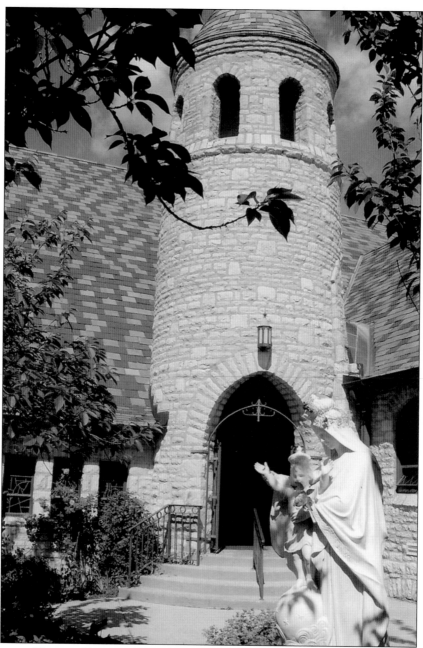

OUR LADY OF VICTORY CHURCH. Erected on a four-acre tract of land on Roxbury Road in Marble Cliff, the site of a 20-room stone house and a hunting lodge, the first mass was said at Our Lady of Victory Church on September 1, 1922. Fr. Thomas A. Nolan was appointed pastor by Bishop James J. Hartley and moved into the lodge, which became the rectory. Father Nolan's dislike of Italians was legendary and his demeanor discouraged many in the surrounding neighborhoods from attending mass there. Several Italian parishioners have said they even remember being chased off the church grounds by Father Nolan, who reportedly told them to go "to their own church." Despite the fact that many Italians felt unwelcome here, there were, and still are, a large number of Italian parishioners at Our Lady of Victory Church. (Courtesy of Dominianni family.)

Two

FAMILY

Italian families, both in Italy and around the world, believe *la famiglia è la patria del cuore*, meaning, "your family is the homeland of your heart." *La famiglia* was at the core of Italian immigrant life and was often seen as the root of survival. Between 1876 and 1924, more than 4.5 million Italians arrived in the United States, with just over 60,000 settling in Ohio. In the earliest phase, the vast majority of these Italian immigrants in Columbus were men in their teens and 20s who planned to work, save money, and eventually return home to Italy. In the end, however, only 20 to 30 percent of these Italian immigrants returned to Italy permanently. The others stayed and made a life for themselves. They worked hard and saved their money, eventually sending for their wives and children, mothers and fathers, and sisters and brothers. Sometimes these hard-fought family reunions were several years in the making.

As these immigrant families were finally reunited in America, quite often many generations lived under one roof. Italian families bought homes near their *paesani* (countrymen), creating many "Little Italy" communities nationwide. Their children played together, they formed Italian social clubs, they attended mass together, and they created larger families through marriage. Over the years, the following generations maintained certain traditions from Italy but also incorporated American values into their Italian culture by marrying outside of their communities and moving away from the old neighborhoods.

Italians in Columbus have achieved great success and accomplished many things in the last century. They still value family and the sense of belonging it provides but no longer feel like outsiders in a strange new world.

As Fr. Casto Marrapese, a former pastor of St. John the Baptist Italian Catholic Church, said on this gradual integration of Italians into their new way of life in the United States, we "have finally discovered that the greatness of this nation consists not in making everybody the same but in the capacity to make all work together for the same purpose. So rather than to a melting pot, I would compare America to a beautiful stained-glass window where each piece maintains its shape, size, and color but all fit together to create a masterpiece."

EZIO CHERUBINI. In 1902, there were approximately 1,100 Italians living in Franklin County, and many of those early immigrants were brought to the United States by Columbus steamship agent Ezio Cherubini, whose offices were at Spruce and Front Streets. Cherubini arrived in Columbus in 1891 and was initially sponsored by his prominent uncle John Marzetti. Cherubini became the area's first Italian banker in 1910 and developed the business block at 509–525 North Park Street. (Courtesy of Grandview Heights/Marble Cliff Historical Society.)

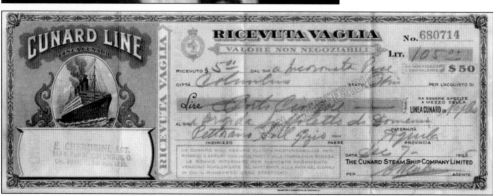

RICEVUTA VAGLIA. Incoronata Pace's "Ricevuta Vaglia" ticket for travel from Italy to Columbus is dated 1925 and bears Ezio Cherubini's name. She, like so many other Italian emigrants from the province of Aquilla, departed from Naples and arrived in the United States on the Cunard Steamship Line. (Courtesy of Carol Ventresca.)

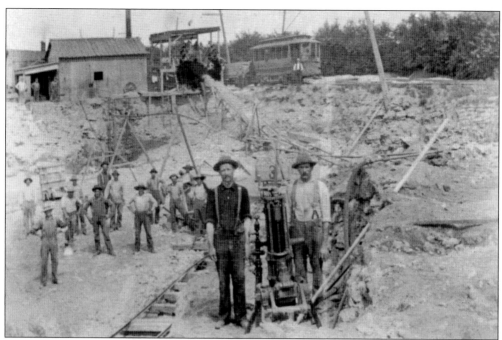

CASPARIS CASTLE AND MARBLE CLIFF QUARRY. Lining both sides of the Scioto River at the end of Fifth Avenue at Dublin Pike was the limestone quarry that provided stone for building (above). Most of the workers in the local quarry were Italian transplants hired by northern Italian immigrant Sylvio Antonio Casparis, the founder of Casparis Stone Company and later Marble Cliff Quarry. Many of the single men lived in the "Italian Club," where rent was $1 a month. Casparis lived on a five-acre estate at 1425 Arlington Avenue. Properly called "Elton House," but commonly referred to as "Casparis Castle" by the locals, the mansion, shown below, and five-story carriage house were built in 1908. From the tower of the carriage house, Casparis could oversee the work being done at the quarry. (Both, courtesy of Grandview Heights/Marble Cliff Historical Society.)

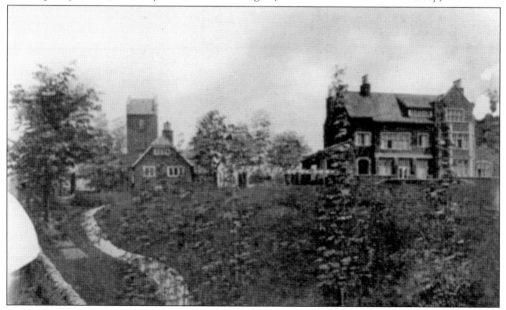

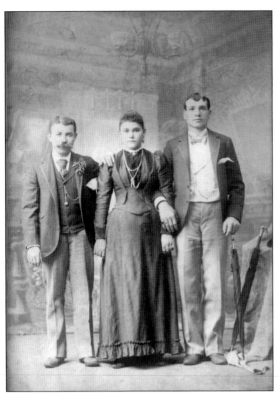

Nicola Cua and Maria Concetta Mango Wedding, October 18, 1893. In the late 1880s, Nicola Cua left Calabria to come to the United States. Upon arriving in Columbus, he befriended a fellow Calabrese, Luigi Mango. With the profits from his fruit stand, Mango sent for his mother and sisters in Calabria. Cua met Mango's sister Maria, and the two were married and had six children. Pictured are, from left to right, Luigi Mango, Maria Concetta Mango, and Nicola Cua. (Courtesy of Cua family.)

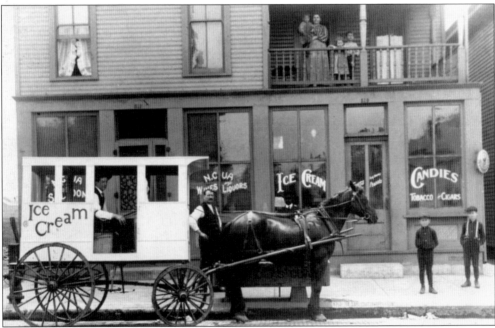

Nicola Cua Saloon, 1905. Nicola Cua and his family are shown standing in front of their two-story home at 315 East Fifth Avenue. The door on the left provided entry to his saloon, where Cua sold beer for 5¢ a glass. The door on the right was the entrance to the family's homemade ice cream shop. The second floor was the living quarters for the family. (Courtesy of Cua family.)

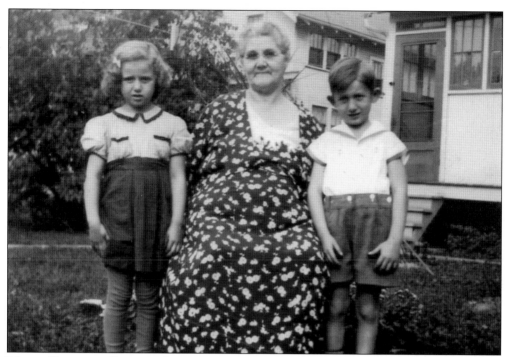

MARIA CONCETTA CUA AND GRANDCHILDREN, C. 1944. Maria Concetta Cua sits with two of her 13 grandchildren, Mary Jeanette Little and Ronald Cua, behind their family home at 2973 Cleveland Avenue. Maria and her husband, Nicola, had five boys, Giovanni, Carmine, Francesco, Michele, and Gerardo, and a daughter, Maria. (Courtesy of Cua family.)

NICOLA CUA. Nicola Cua (left) retired in the late 1930s, selling his business and leasing his building to a roofing company. On Christmas Eve 1942, while doing some last minute shopping, Nicola was crossing Spring and High Streets in downtown Columbus when a streetcar ran a red light and hit him, pinning him under the wheel. He was rushed to the hospital, where he died a few hours later from shock. (Courtesy of Cua family.)

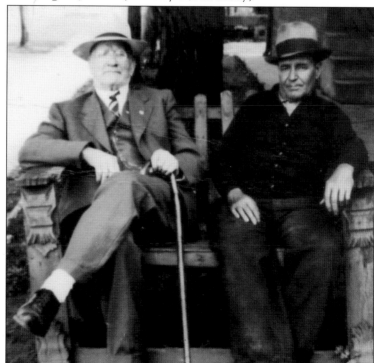

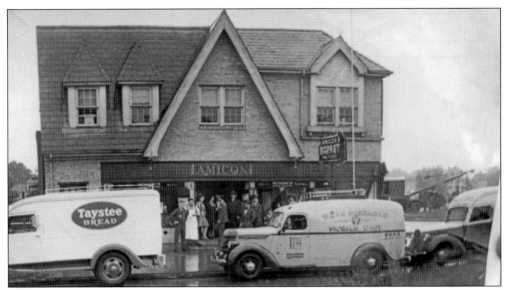

AMICON MARKET. Gus Amicon, shown above wearing an apron, stands outside of his market in 1938. Gus and his brother Rocco came to the United States from Castel Di Sangro, Italy, in the province of L'Aquila, Abruzzo, in the early 1920s, sponsored by their uncles, who owned a large produce warehouse downtown. They built Amicon Market at the corner of Fairview and Fifth Avenues in 1930, with a chicken coop out back to provide fresh poultry. In 1940, Gus opened his own store on First Avenue, and in 1946, Rocco opened a restaurant in an addition next door. Rocco Amicon, shown below at the far right of the market, was well known for saying, "If a person can't make it here in America, it's their own fault, because the opportunity is here." (Both, courtesy of Grandview Heights/Marble Cliff Historical Society.)

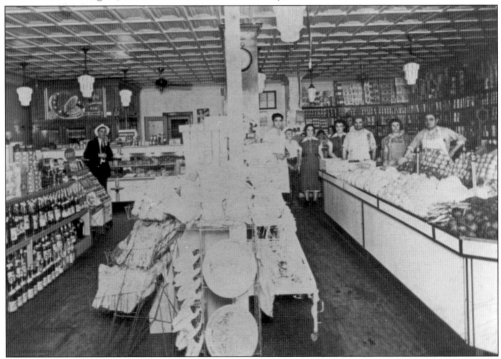

PISCITELLI FAMILY. In 1903, Alfonso Piscitelli left Santa Maria a Vico, Italy, in the province of Caserta, Campania, for a better life in Columbus. He met Maria Valentino, and the two were married at St. John the Baptist Italian Catholic Church by Fr. Rocco Petrarca on May 12, 1921. They had four children, seven grandchildren, and eight great-grandchildren. They lived at 665 Hamlet Street in what is now called Italian Village. Pictured in front of their mother Maria are, from left to right, Giuseppe, Lorenzo, and Maria in 1930. Pictured below in 1926 is Maria Valentino Piscitelli holding her eldest daughter Maria in the backyard of the family's home. Notice the grape arbor and lattice fencing constructed by Alfonso. (Both, courtesy of Joseph Piscitelli.)

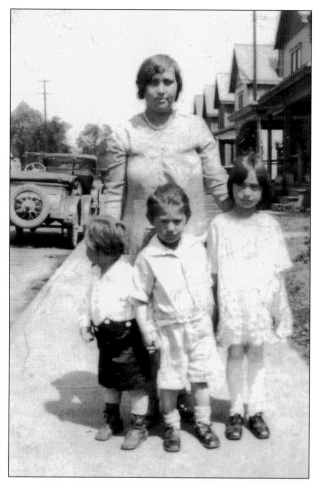

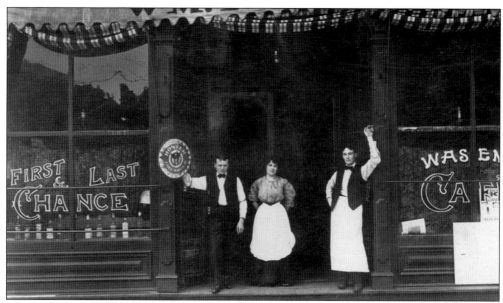

First and Last Chance Saloon. Salvatore Presutti, who came to Columbus from Pratola Peligna, Italy in the province of L'Aquila, Abruzzo, and his brother Emmitt opened the First and Last Chance Saloon at 409 West Goodale Street in Flytown in 1908. This was a popular watering hole for the immigrants in this melting pot neighborhood until Prohibition destroyed the business in 1919. (Courtesy of Richard E. Barrett.)

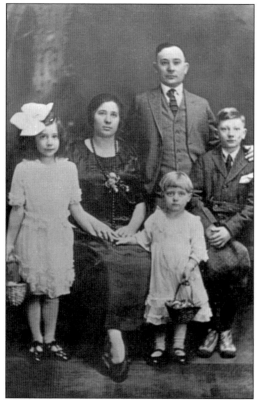

Presutti Family, Easter, 1923. In October 1914, Salvatore Presutti married Rosina Gualteri, who had also come to Columbus from Abruzzo. They would eventually move into a large brick home at 1692 West Fifth Avenue and, in 1920, opened an Italian restaurant in the lower level of their home, called Presutti's Villa. They are pictured here with their three children, from left to right, Eda, Evelyn, and Alfredo. (Courtesy of Grandview Heights/Marble Cliff Historical Society.)

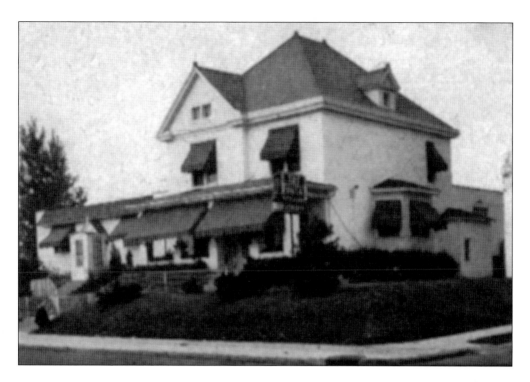

PRESUTTI'S VILLA. Presutti's Villa (above) was a popular place for wedding receptions, and Salvatore and Rosina were affectionately referred to as "Papa and Mama Presutti" by their many regulars. Over time, Presutti's Villa was expanded and run by their son Alfredo "Rocco" and his son Salvatore "Sully." Three generations of Presuttis are pictured below, from left to right, Salvatore, Alfredo, and Sully. After a kitchen fire in the early 1980s, this local favorite closed its doors forever but remains one of the most legendary of all Columbus restaurants. (Both, courtesy of Grandview Heights/Marble Cliff Historical Society.)

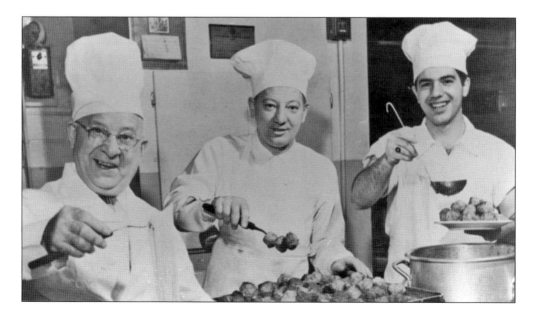

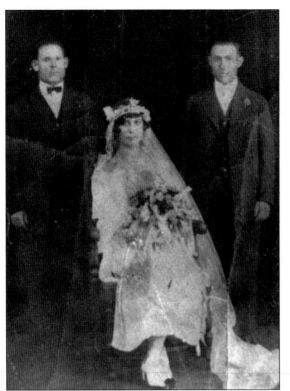

FORTUNATO MERULLO AND ASSUNTA "SUSIE" VERRILLI WEDDING, AUGUST 22, 1925. Fortunato Merullo and Assunta "Susie" Verrilli were married in 1925 at St. John the Baptist Italian Catholic Church. Fortunato was born in Santa Lucia, in the province of Messina, Sicily, in 1893. Assunta was born to Italian immigrants in Columbus in 1908 and lived in the Bottoms neighborhood with her parents until the great flood of 1913 forced them to move. The Verrilli family purchased a home on West Third Avenue in Grandview Heights using funds granted to them by the Italian government. Pictured at left are, from left to right, best man and first cousin of the groom Salvatore Merullo; Assunta "Susie" Verrilli; and Fortunato Merullo. (Courtesy of Felix Merullo.)

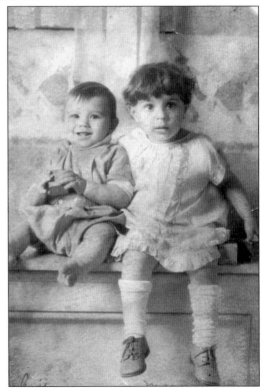

MERULLO CHILDREN. Pictured at right are two of Fortunato and Assunta Merullo's seven children, Mary (left) and Felix, in 1928. (Courtesy of Felix Merullo.)

MERULLO FAMILY, 1929.
Fortunato and Assunta
Merullo lived on Kingrey
Street in Columbus's
Milo neighborhood and
had seven children. They
eventually moved to the
Linden neighborhood at
1780 Windsor Avenue.
From left to right are (first
row) Sam, Josephine,
Victor, Dan, and
Fortunato; (second row)
Mary, Assunta, Felix,
and Pasquale. (Courtesy
of Felix Merullo.)

FELIX MERULLO. Felix, the oldest son of
Fortunato and Assunta Merullo, entered the
service in January 1946 after six months at
Ohio State University. He was stationed in
Japan and eventually returned home to work
in his father's landscaping business, Merullo's
Nursery. (Courtesy of Felix Merullo.)

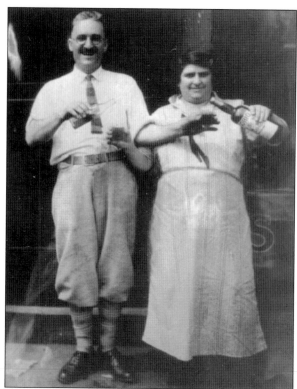

GIUSEPPE AND MARIA FRACASSO, c. 1926. Famous for wearing knickers everywhere he went, Giuseppe Fracasso poses with his wife, Maria, in front of their store at 807 St. Clair Avenue. Giuseppe and Maria both came to Columbus from Introdacqua, Italy, in the province of L'Aquila, Abruzzo. They opened Fracasso's Grocery Store in 1918, allowing other Italians in the neighborhood to run tabs on a handwritten ledger. The couple and their 10 children, seven boys and three girls, lived above the store. Giuseppe was a founding member of the Societa Fratellanza D'Introdacqua, a social service group that exists to this day. (Courtesy of George Bleimes.)

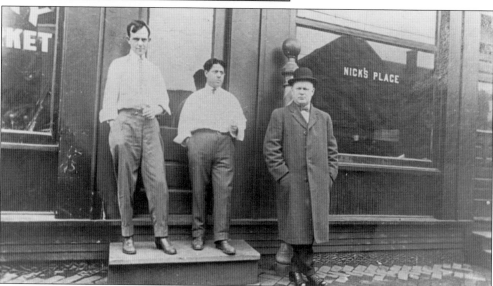

NICHOLAS BOTTI. Nicholas Botti was born in Rutino, Italy, in the province of Salerno, Campania, in 1887 and arrived in Columbus, alone, at the age of 16. Botti was taken in by the Adorno family, whose own son Nicholas had died. He worked in the Adorno family grocery store delivering beer, wine, and whiskey by horse-drawn wagon to the construction crews building Griggs Dam before opening his own barbershop, called "Nick's Place," on Goodale Street in 1912. Pictured here around 1912 are Nicholas Botti (middle) and two friends. (Courtesy of Grandview Heights/ Marble Cliff Historical Society.)

ROSSI FAMILY. Pictured are, from left to right, Lena Rossi, Enrichetta Rossi, and Arthur Rossi in March 1929. Enrichetta, along with her children and husband, Carmine, lived on Glenn Avenue in Grandview Heights. Eventually, Carmine and Enrichetta had two more children, Norma and Yola. They attended weekly mass at St. John the Baptist Italian Catholic Church, taking three bus transfers every Sunday to get there. Enrichetta worked as a seamstress, and Carmine worked as a stone mason, having come to Columbus from Abruzzo. (Courtesy of Yola Marie Rossi.)

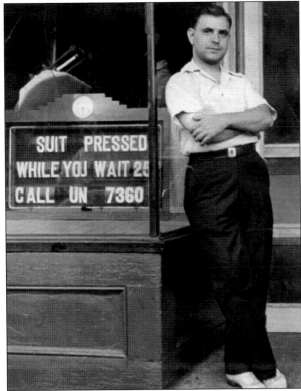

EGISTO DEL GRECO. Pictured here is Egisto Del Greco in 1935 outside of Del Cleaners, which he owned, located at Fifth and Cleveland Avenues in Columbus's Milo neighborhood. On September 4, 1937, at St. John the Baptist Italian Catholic Church, Del Greco married Viola Verne, whose family operated the nearby Verne's Café. The couple had three children, Anita, Rita, and Frank. (Courtesy of Del Greco family.)

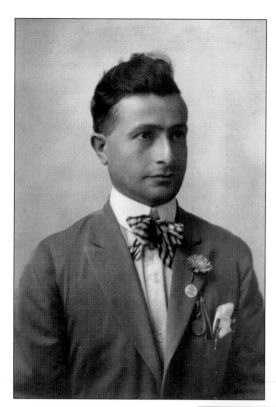

PASQUALE CENCI. Pasquale Cenci immigrated to Columbus from Vastogiradi, Italy, in the province of Isernia, Molise, in 1912. He, along with his brother Nicholas, opened a bar at 790 St. Clair Avenue and later built the Cenci Bros. Market at West Fifth and Glenn Avenues in Grandview Heights. Pasquale and his wife, Adelina, became charter members of Our Lady of Victory Church and lent money to Leonida Vellani to pay for the passage of his wife and children to the United States. (Courtesy of Vellani/Sabino families.)

LEONIDA TRANQUILLO VELLANI. Leonida Tranquillo Vellani was born on March 30, 1885, in Canolo Di Correggio, Italy, in the province of Reggio Emilia, Emilia Romagna, and came to Columbus at the urging of his friend Giovanni Trolli in 1913. Two years later, Leonida's wife, Virginia, and their four young children arrived at Ellis Island and boarded a train to meet him in Ohio. (Courtesy of Vellani/Sabino families.)

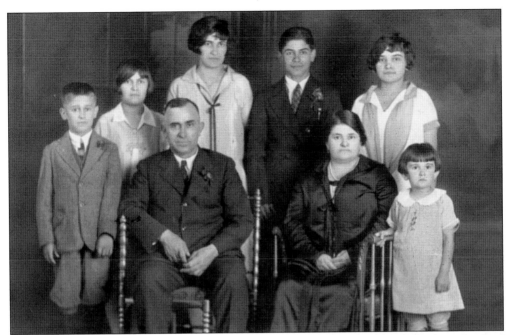

VELLANI FAMILY, 1926. Leonida and Virgina Vellani settled in south Columbus, where they had two more children and Leonida found work as a molder in the Bonney-Floyd steel mill. From left to right are (first row) Alberto, Leonida, Virgina, and Emma; (second row) Elena, Disolina, Bruno, and Maria. (Courtesy of Vellani/Sabino families.)

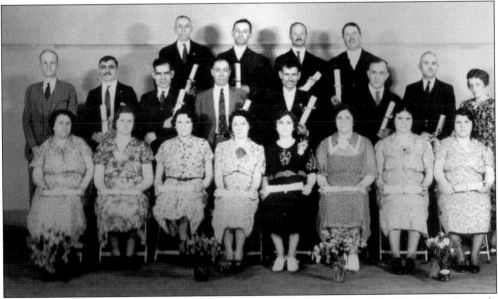

LEONIDA VELLANI NATURALIZATION CLASS. In 1931, during the height of the Depression, Leonida Vellani was laid off from his job in Columbus and returned to Italy to find the economic situation was even worse there. He eventually returned to Columbus and, 25 years after first arriving in the United States, he was naturalized as an American citizen. Pictured here (in the second row, sixth from the left) is Vellani in his naturalization class in Columbus in 1937. (Courtesy of Vellani/ Sabino families.)

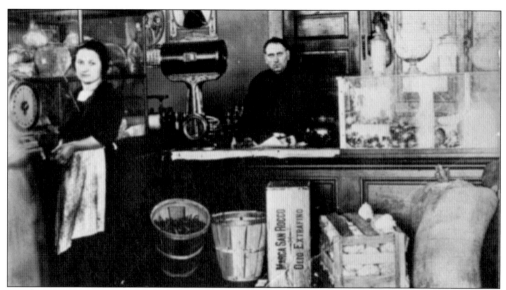

DiPaolo Food Shoppe. Paolo and Louisa DiPaolo (above) came from Introdacqua, Italy, in the province of L'Aquila, Abruzzo, and, in 1915, opened DiPaolo Food Shoppe in a basement on St. Clair Avenue using Paolo's railroad bonus money. To keep customers coming back, Louisa would often give them pillowcases or sheets. After Louisa died, Paolo and son Richard "Richie" (below) operated a larger DiPaolo Food Shoppe also located on St. Clair Avenue for many years, selling loose pasta in 20-pound crates. This small immigrant grocery store would eventually become a $75-million food distribution empire that was sold to Sysco Food Service in 1985. Pictured are, from left to right, a customer, Mary Lou Casanta, Frankie Casanta, Paolo DiPaolo, Louise DiPaolo, Rose Crognel, Rita DiPaolo, and Richie DiPaolo. (Both, courtesy of Paul DiPaolo.)

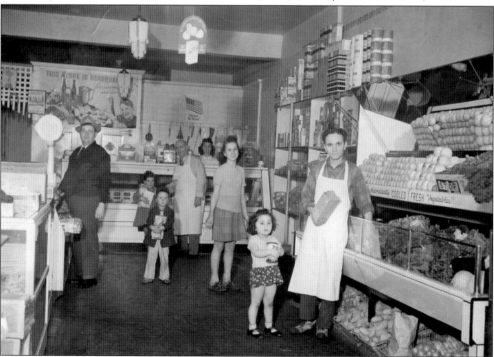

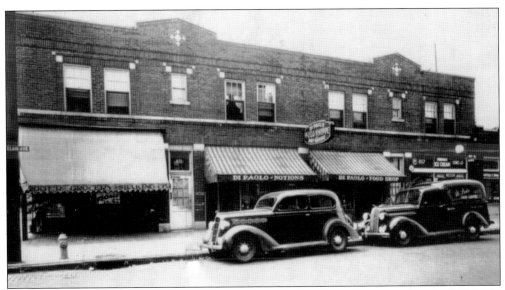

EXTERIOR OF DiPAOLO FOOD SHOPPE. A well-known importer of authentic Italian food, DiPaolo Food Shoppe (above) served the Italian community of St. Clair Avenue for many decades until the 1960s, when the immigrants largely disbanded for newer homes in the suburbs. Ever resourceful, Richie DiPaolo started DiPaolo Food Distributors, supplying ingredients to the growing number of pizza houses in Columbus. With his children Rita, Paul, and Dick in the back of the car, Richie would personally call on local pizza parlors to take their orders. Among the pizza "inventions" credited to Richie DiPaolo that remain in use to this day are the silver dollar–size pepperoni slice and the pizza box. Richie and his wife Josephine (below) were high school sweethearts and neighbors in the St. Clair Avenue area. They celebrated their golden anniversary in 1988. (Above, courtesy of Paul DiPaolo; below, courtesy of the *Columbus Dispatch*.)

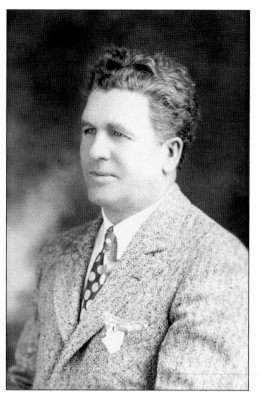

JOSEPH PRIORE. Joseph Priore (left) was born in Atena Lucana, Italy, in the province of Salerno, Campania, and came to New York in 1895 at the age of 23 with $6 in his pocket. He worked as a shoeshine boy with regular clients, including Teddy Roosevelt and J.P. Morgan. After moving to Columbus in 1908, Priore opened a successful real estate business and became well known for his generosity and concern for fellow Italian immigrants. Priore is credited with saving the homes of other Italians who had fallen behind with the bank and is perhaps best remembered for his trademark phrase, "*ci vuole la santa pazienza,*" meaning, "you have to have the patience of a saint." (Courtesy of Roger Rill.)

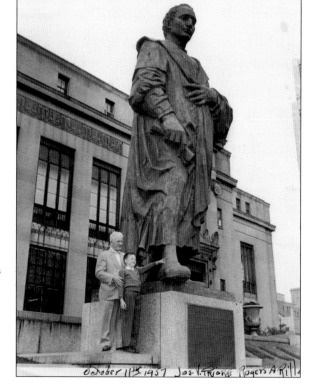

COLUMBUS DAY, 1957. On Columbus Day 1957, Joseph Priore was honored by the City of Columbus as a prominent Italian in the community. He is pictured (right) with his oldest grandchild, Roger Rill, age seven, at the statue of Christopher Columbus. (Courtesy of Roger Rill.)

Roman DiSabato and Lucille Bernard Wedding, June 23, 1929. Roman Julius DiSabato and Lucille Bernard were married (right) at St. Francis of Assisi Catholic Church in 1929. Roman owned a pool hall on Goodale Street in Flytown but would later become a welder at Yaeger Machine Company. The family suffered incredible tragedy over the years. They had five boys but lost three of them. Their twins died at birth, and another son died, of pneumonia, in infancy. (Courtesy of DiSabato family.)

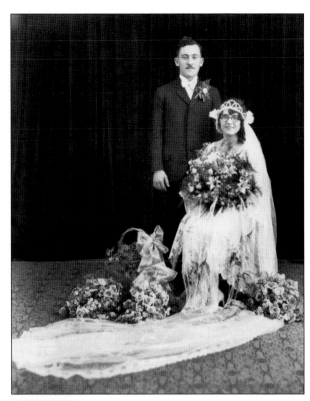

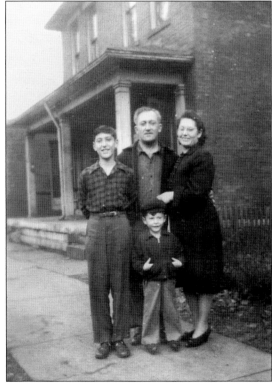

DiSabato Family. The couple and their remaining sons Louis (left) and Paul lived at 728 Delaware Avenue in Flytown. Roman, to make extra money, volunteered for a welding job that required him to get inside a cement mixer, and the metal fumes from the welding torch caused him to develop lung cancer. He passed away at the age of 42. (Courtesy of DiSabato family.)

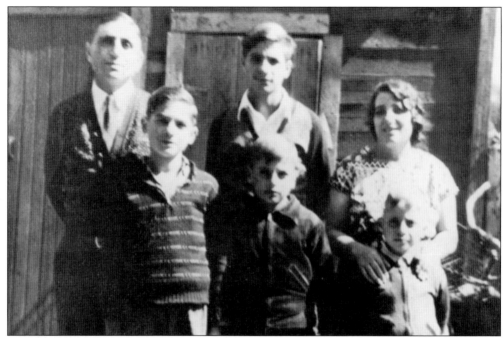

D'ANDREA FAMILY, C. 1940. Anthony and Antoinette D'Andrea came to Columbus in June 1920 from San Bartolomeo in Galdo, Italy, in the province of Benevento, Campania. The family lived at 910 St. Clair Avenue in the largely Italian neighborhood of Milo. From left to right are (first row) Ettore, Edmund, and Ermo; (second row) Anthony, Attilio, and Antoinette. (Courtesy of D'Andrea family.)

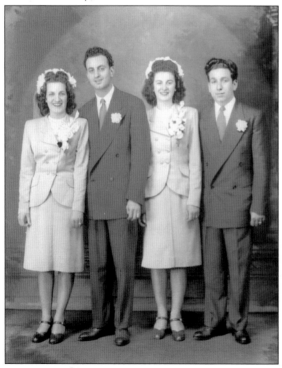

VENTRESCO WEDS D'ANDREA— D'ANDREA WEDS VENTRESCO, JUNE 8, 1947. From left to right, Josephine D'Andrea and Pasquale Ventresco and Lucy Ventresco and Teddy D'Andrea, two brother-sister combinations, were married in 1947 at St. John the Baptist Italian Catholic Church by Fr. Rocco Petrarca. The D'Andrea family emigrated from San Bartolomeo in Galdo, and the Ventresco family came from Introdacqua, Italy, in the province of L'Aquila, Abruzzo. Pasquale and Josephine had one daughter, Jo Ann. Teddy and Lucy had two sons, John and Tom. Both Pasquale and Teddy worked for the Pennsylvania Railroad for many years. (Courtesy of Ventresco/D'Andrea families.)

NEWLYWEDS EUGENE AND MARY PELINO. This photograph was taken on June 3, 1932, the day after Introdacqua native Eugene Pelino married Mary Tucci, whose parents were Italian immigrants. They moved to the St. Clair Avenue area, and Eugene found work at the Smith Shoe Factory. The couple had five children, Mary Jane, Esther Rose, Vincent Eugene, Violet Jean, and Anthony Dominic. (Courtesy of Pelino/Caminiti families.)

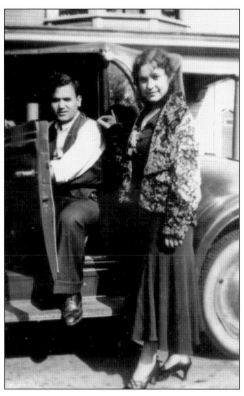

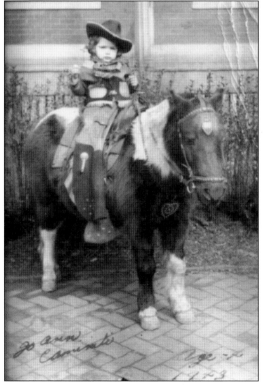

JOANN CAMINITI ON A PONY. Four-year-old Joann Caminiti is pictured here on a pony that she loved in 1943. She was the youngest of Italian immigrants Domenico and Maria (Ciminello) Caminiti's 10 children. This photograph was taken outside the family's home, where Joann was born, at 166 East Warren Street in Italian Village. The family would soon move to 776 Gibbard Avenue near St. Clair Avenue. (Courtesy of Pelino/Caminiti families.)

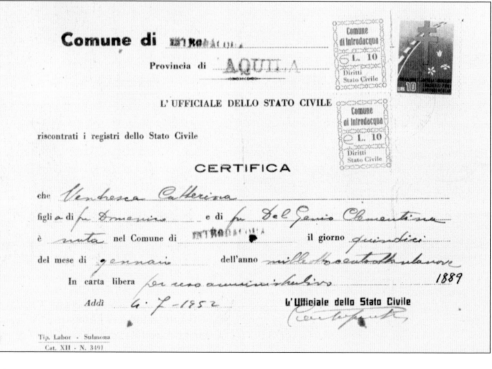

RAFFAELLE TRAPASSO AND CATTERINA VENTRESCA OFFICIAL DOCUMENTS. Raffaelle Trapasso was born on February 28, 1883, in Catanzaro, Italy, and came to the United States in 1903 on the SS *Cambroman*. He eventually made his way to Columbus to work at the New York Central Railroad, originally settling in Flytown. This is a copy of his Declaration of Intention to become an American citizen on December 29, 1939. Catterina Ventresca was born in Introdacqua, Italy, in the province of L'Aquila, Abruzzo, on January 15, 1889. Throughout her life, she learned very little English, remaining true to her Italian roots. She was also a dedicated mother and grandmother. Below is a copy of her birth certificate. (Both, courtesy of Trapasso family.)

RAFFAELLE TRAPASSO AND CATTERINA VENTRESCA WEDDING, 1909. Raffaelle Trapasso and Catterina Ventresca were married at St. John the Baptist Italian Catholic Church, settling on Sycamore Street in Columbus and raising nine children, Josephine, Mary, Michael, Clementine, Dominic, Frank, Angeline, Susie, and Margaret. Catterina, a devout Catholic, attended mass three times every Sunday and cooked traditional Italian Sunday dinners for the family. (Courtesy of Trapasso family.)

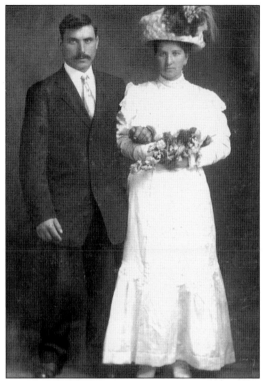

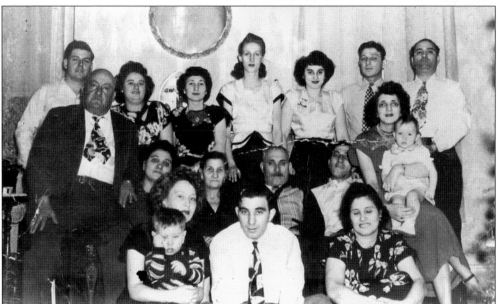

TRAPASSO FAMILY, C. 1950. Trapasso family members are, from left to right, (first row) Helen Trapasso, Johnny Trapasso, Frank Trapasso, and Mary DiVito; (second row) Ben Canini, Josephine (Trapasso) Canini, Catterina (Ventresca) Trapasso, Raffaelle Trapasso, Dominic Trapasso, Angeline Trapasso, and Mary Ann Ogburn; (third row) Lester Ogburn, Margaret (Trapasso) Ogburn, Susie Trapasso, Delores Trapasso, Viola DiVito, Mike Trapasso, and Ralph DiVito. (Courtesy of Trapasso family.)

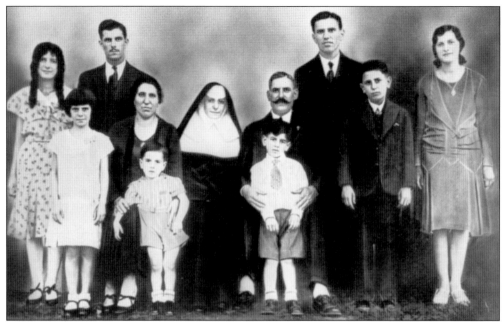

BOLOGNONE FAMILY, 1931. Antonio Bolognone and Maria (Melfi) Bolognone both came to Columbus from Celle Di San Vito, Italy, in the province of Foggia, Puglia. Antonio arrived in 1905, and Maria came two years later. They settled at 831 West Gay Street in the Bottoms neighborhood and had nine children. Antonio worked at the Pennsylvania Railroad. Pictured are, from left to right, Elvera, Josephine, Daniel, Maria, Rudy, Sr. Mary Anthony (Lucia), Antonio, Michael, John, James, and Rosella. (Courtesy of Bolognone family.)

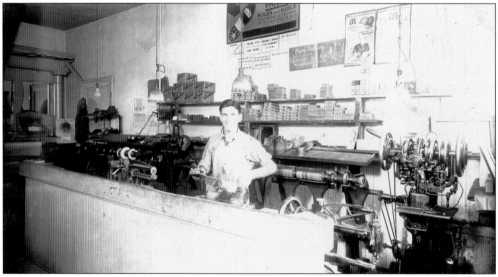

JOHNNY'S SHOE REPAIR AND LEATHER CRAFT. John Bolognone was the second of Antonio and Maria Bolognone's nine children and operated a shoe repair and leather craft store at 963 West Broad Street. Known as much for his compassion as his craftsmanship, Bolognone would hire the physically disabled and teach them the trade of shoe repair. Although he never graduated from high school, he went on to teach leather crafting at the Ohio State School for the Deaf for 25 years. (Courtesy of Bolognone family.)

THE D'IPPOLITO FAMILY, 1927. Giuseppe D'Ippolito was born March 19, 1895, in Sessano, Italy, in the province of Isernia, Molise, and came to the United States at the age of 16. He traveled home to Italy in 1920 to marry Assunta Sciarra, and the couple returned to Columbus later that year. Giuseppe worked for more than 40 years at the Marble Cliff Quarry and used stone from the quarry to build his home, where they raised four children, Helen, Linda, Mary, and Joseph. Pictured are, from left to right, Helen, Assunta, Giuseppe, and Linda. Giuseppe's craftsmanship (below) during the Depression era is admired by his son Joseph. (Both, courtesy of Lisa D'Ippolito McIsaac.)

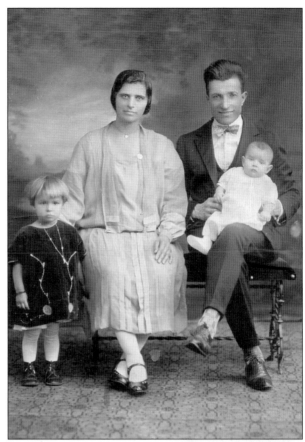

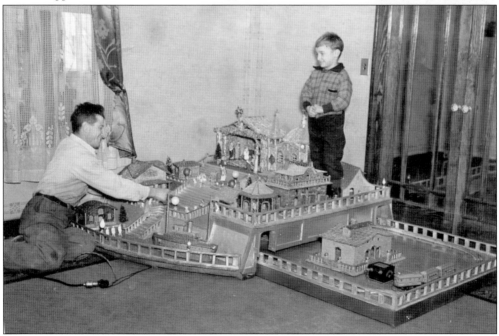

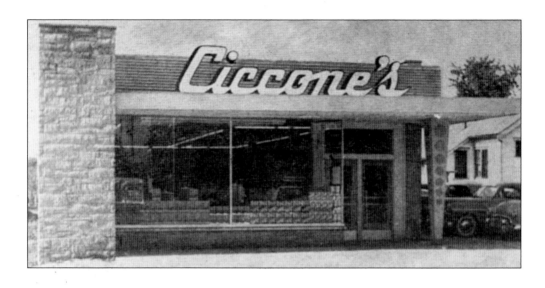

CICCONE'S MARKET. Italian immigrants Biase and Maria Ciccone moved into a two-story home in Grandview Heights on the northwest corner of Westwood and Third Avenues in 1923 and operated a grocery store on the first floor. In 1933, they moved the store across the street, where sons Jim and Gildo helped their mother, while Biase managed the Knotty Pine Bar in the west side of the building. In 1951, on the property now occupied by the Columbus Italian Club at 1739 West Third Avenue, the Ciccones built the newest home for their grocery store (above). Pictured below are, from left to right, Biase Ciccone, Pat Mearagno, and Jim Ciccone. (Both, courtesy of Grandview Heights/Marble Cliff Historical Society.)

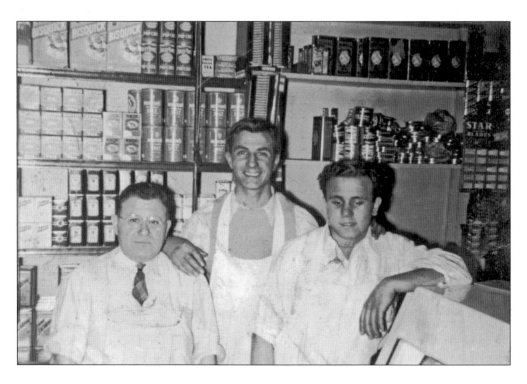

GAETANO FERRELLI. Gaetano Ferrelli was born in 1856 in Pettorano Sul Gizio, Italy, in the province of L'Aquila, Abruzzo. After immigrating to the United States, Ferrelli, like so many other Italians in Columbus, found work at the Marble Cliff Quarry, which was owned by an Italian immigrant family. Ferrelli, who eventually married and had four children, died in 1930. (Courtesy of Gloria Di Pietro.)

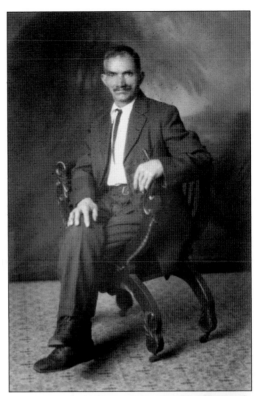

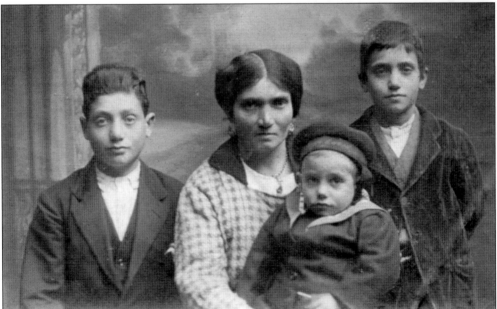

MARIA FERRILLI D'AMICO AND CHILDREN. Giovanni D'Amico left Italy and found work in Columbus with the railroad, and in 1919, his wife, Maria, their daughter, and three sons joined him. They originally settled in Marble Cliff but later moved to Westwood Avenue in Grandview Heights and had three more children. Pictured are, from left to right, Joseph, Maria, and Lawrence. Donato is sitting on Maria's lap. (Courtesy of Gloria Di Pietro.)

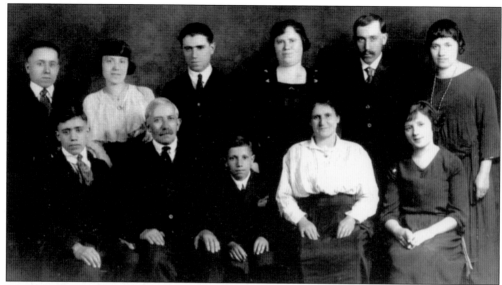

ARATA FAMILY, 1920. The Arata family immigrated to Columbus in stages from Orero, Italy, in the province of Genoa, Liguria, beginning in 1905. The eldest daughter, 16-year-old Camilla, was the first to travel to the United States, where she worked as a housekeeper for Louise Sanguinetti. With the money she earned and some help from Sanguinetti, Camilla was able to pay for her mother and four siblings to come to Columbus in 1909. Pictured are, from left to right, (standing) Paul, Marie, John, Felichia "Rose," Louis, and Camilla; (sitting) Angelo, John, Albert, Madalena, and Ellen. (Courtesy of Arata/Angelo families.)

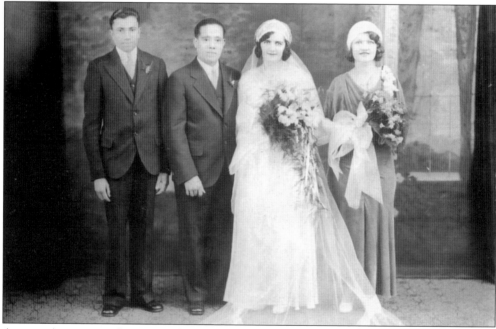

ANGELO ARATA AND CATHERINE SMITH WEDDING, OCTOBER 22, 1931. Angelo and Catherine Arata are pictured here on their wedding day in 1931 with brother of the groom Albert Arata and sister of the bride Josephine Smith. Angelo, who retired at age 73 from Ebco Manufacturing, and Catherine had three sons and one daughter. (Courtesy of Arata/Angelo families.)

LUIGI AND LUIGIA CAMPAGNA, C. 1920.
Having emigrated at different times from
Castions Di Zoppola, Italy, in the province of
Pordenone, Fruili-Venezia Giulia, Luigi and
Luigia (Borean) Campagna were married in
1920 at St. John the Baptist Italian Catholic
Church by Fr. Rocco Petrarca. Luigi came
first, rooming with family friends from
Pordonone, and began corresponding with
Luigia back home. He would eventually
convince her to move to Columbus on the
promise that they would return to Italy after
a few years. They never did. The Campagnas
had five daughters, and it was 50 years
before Luigia returned to Italy for a month-
long visit with the family she left behind.
(Courtesy of Teresa Campagna Behal.)

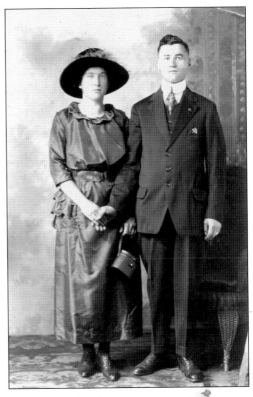

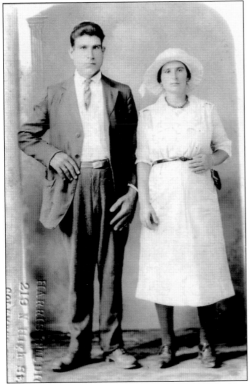

SALVATORE AND FELICIA (GIAMPÁ) SESTITO.
Salvatore Sestito (left) came from Borgia,
Italy, in the province of Catanzaro, Calabria,
to the United States by way of Ellis Island
in 1905. He married Felicia Giampá, also
from Calabria, by proxy in 1920, and
she soon joined him in Columbus. The
Sestitos settled in German Village and had
five children, Rosemary, Thomas, Bruno,
Barbara, and Dominic, and a number of
grandchildren. (Courtesy of Sestito family.)

59

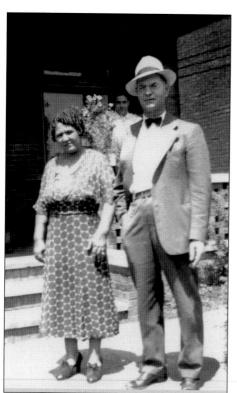

MICHAELANGELO AND MARIA (SADELLA) GAGLIO. Michaelangelo and Maria Gaglio are shown outside their home at 412 Buttles Avenue in the Flytown neighborhood. Michaelangelo was born in 1882 in Messina, Italy, in the province of Messina, Sicily, and Maria was born in 1896 in Bari, in the province of Bari, Apulia. They were married in Syracuse, New York, and moved to Columbus, Ohio, to start a family and a business. Michaelangelo became co-owner of the Italian American Restaurant at the corner of Harrison Avenue and Goodale Street in Flytown. The Gaglios had seven children. (Courtesy of Pat Weimer.)

THE D'ALESSIO FAMILY DAIRY FARM, C. 1930. The D'Alessio "Dallas" family was the only one in the largely Italian neighborhood of San Margherita to have cows on their property, providing milk service to their neighbors. The Dallas children delivered the milk in glass bottles by wagon. Pictured on the Dallas property on McKinley Avenue near Trabue Road are, from left to right, Evelyn, Violet, and Nell. (Courtesy of Helen Morrison.)

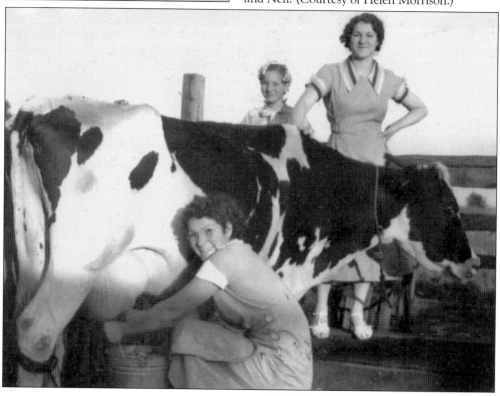

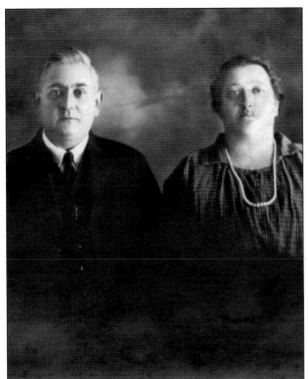
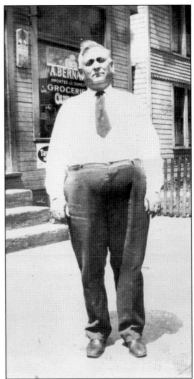

ALEX AND CARMELLA (CASBARRO) BONORA. Alex and Carmella (Casbarro) Bonora came to Columbus from Salerno when they were teenagers in the late 1880s. Alex's last name was changed to Bernard. They were married at St. Francis of Assisi Church and had nine children. Pictured (above, right) is Alex Bernard in front of the family-owned A.J. Bernard Grocery Store in the Flytown neighborhood, which was located there for many years. Pictured below are, from left to right, (sitting) Alex Bernard; (standing) sons-in-law Joe Bucci, Joe Rosetti, and Roman DiSabato on a friend's hunting property in Delaware County. (All, courtesy of Paul DiSabato.)

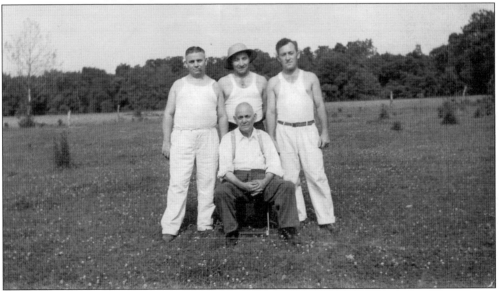

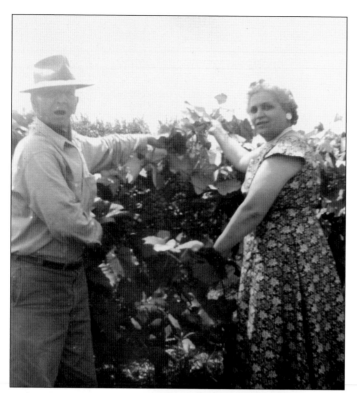

PANFILO LANCIA AND NIECE, C. 1914. Panfilo Lancia was born in Pettorano Sul Gizio, Italy, in the province of L'Aquila, Abruzzo. He arrived at Ellis Island in 1902 at the age of 23, never to see his parents again. After working in a mine in Steubenville, Ohio, he contracted Lyme disease, which caused him to lose all of his hair. He and his wife, Contetina, moved to Columbus in 1911, and he worked at the Marble Cliff Quarry for 37 years. He was forced to retire at the age of 73 so that younger men could continue to be employed. Pictured in the family vineyard is Lancia with his niece Mary. (Courtesy of Lancia/Shaffer families.)

LANCIA FAMILY HOME. The Lancia family settled in Columbus's largely Italian enclave of San Margherita, and two of their 11 children occupy the family's house at 3413 Trabue Road to this day. The vineyard that Panfilo Lancia planted behind their home was the largest in the area, producing more than a dozen 55-gallon jugs of wine every year. Panfilo and Contetina Lancia are pictured here in front of their vineyard surrounded by family and friends. (Courtesy of Lancia/ Shaffer families.)

JOHN SHAFFER AND DURNA LANCIA WEDDING, AUGUST 4, 1951. The Lancias' youngest daughter, Durna, married John W. Shaffer at St. Margaret of Cortona Church after the two met on a blind date. John had taken Durna to the famous "Snow Bowl," Ohio State versus Michigan, in 1950, and the blizzard that followed forced him to spend the night at her family's home in San Margherita. They had their wedding reception at the Gloria Nightclub. (Courtesy of Lancia/Shaffer families.)

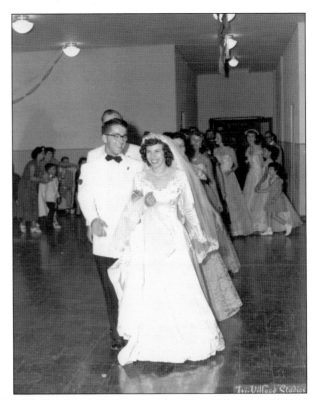

LANCIA FAMILY REUNION. In recent years, John and Durna Shaffer's son Bill has organized an annual family reunion at the house where his mother and aunt Teresa have lived their entire lives. The reunion is open to all extended family and friends, complete with live music, Italian food, and games. (Courtesy of Lancia/Shaffer families.)

CARMINE "ROCKY" AGRIESTI.
Carmine "Rocky" Agriesti (left) was born on March 9, 1898, in Cella, Italy, in the province of Foggia, Apulia, and served in the Italian army during World War I. When the war ended, he came to the United States in 1921, arriving on the *Regina D'Italia*, which sank on its return voyage. After settling in Columbus, Carmine and Rose Penzone (below) were married on October 6, 1928, at St. John the Baptist Italian Catholic Church, and the couple had six children. Rose's family had come to Columbus from Messina, Sicily. (Both, courtesy of Agriesti family.)

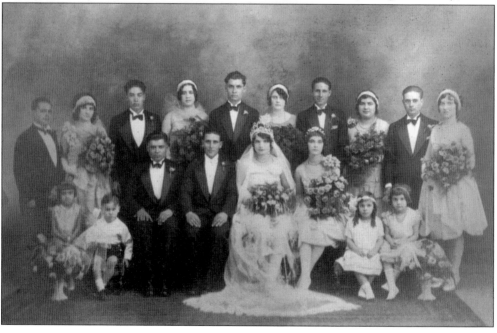

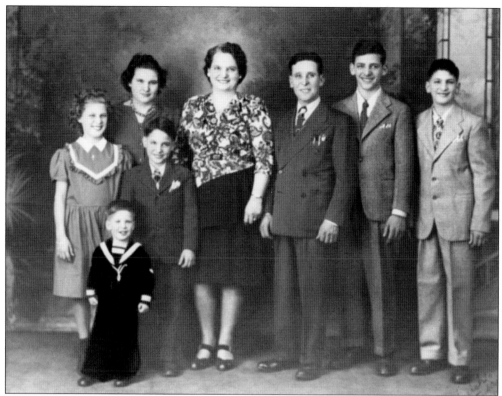

AGRIESTI FAMILY. The Agriesti family lived on Goodale Street in Flytown. Pictured are, from left to right, Dolores, Mary Sue, Rose (Penzone) Agriesti, Carmine Agriesti, Joseph, and John. Pictured in front are Charlie and Anthony. Several family members operated the well-known Agriesti Grill on North High Street for many years. Carmine (below) also ran a successful contracting business for more than 40 years. (Both, courtesy of Agriesti family.)

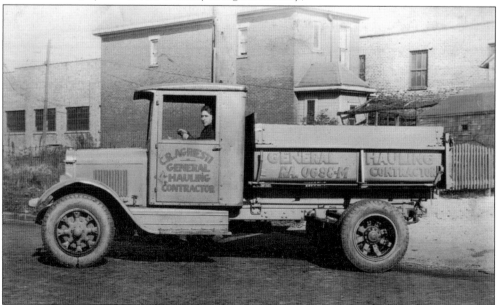

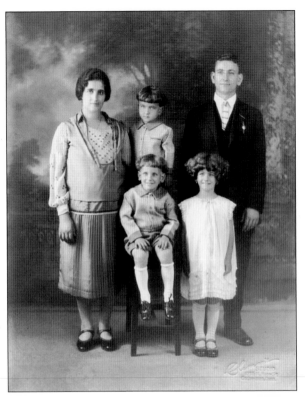

VENTRESCA FAMILY, C. 1926.
Francesco and Pasqua Ventresca
were both born in Introdacqua,
Italy, in the province of L'Aquila,
Abruzzo, and lived on Second
Avenue in the St. Clair Avenue
neighborhood. Before Pasqua passed
away at the age of 94, she made
arrangements for their beloved
house to stay in the family. The
home was purchased by a cousin.
They are pictured here with
three of their four children, from
left to right, (first row) Nicolo
and Philomena; (second row)
Pasqua, Carlo, and Francesco.
(Courtesy of Carol Ventresca.)

SANFILLIPO FAMILY. Sicilian immigrant
Salvatore SanFilippo arrived in Columbus
in 1899, establishing a retail fruit stand
near downtown Columbus. After six
years, he had raised enough money to
purchase three steerage tickets for his
wife, Vincencina, and two sons, Giuseppe
and Guiliano, to join him in the United
States. They arrived in New York Harbor
on Thanksgiving Day 1905, and their
family name was promptly changed at
Ellis Island to Sanfillipo. Salvatore and
Vincencina would have three more
children, Lucia, Maria, and Salvatore.
Their father was murdered in a robbery
on March 22, 1911, just two blocks from
the family's home on West Naughten
Street. (Courtesy of Jimmy Sanfillipo.)

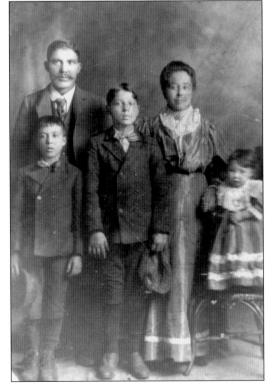

SANFILLIPO PRODUCE COMPANY, 1984. Carrying on the family tradition, Sanfillipo Produce Company was founded by Jim Sanfillipo, great-grandson of Salvatore Sanfillipo, and his wife, Margie, in 1981 at 245 Mount Vernon Avenue in downtown Columbus. Within a few years, Jim's uncle Joe was working for him on a part-time basis and would be instrumental in growing the business into the large-scale produce distribution company it is today. (Courtesy of Jimmy Sanfillipo.)

SANFILLIPO PRODUCE TERMINAL. The Sanfillipo Produce Company has since moved from downtown Columbus into the Columbus Produce Terminal on East Fifth Avenue, near Port Columbus International Airport, where it occupies five of the 20 bays and runs a brisk cash-and-carry business. It remains a family company, run by Jim and his son Jamie. Pictured are, from left to right, Jim Sanfillipo, uncle Joe Sanfillipo, and Jamie Sanfillipo. (Courtesy of Jimmy Sanfillipo.)

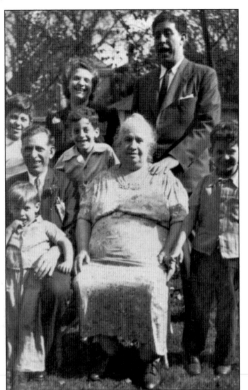

CORROVA FAMILY, C. 1940. Italian immigrants Antonio Corrova and Rosalie (Calabrese) Corrova were born in Ficarra, Italy, in the province of Messina, Sicily. Antonio and son Pete arrived in Columbus in 1911. Antonio worked at Columbus Steel and Iron but fell to his death hours before he would have retired when he leaned over a railing that gave way. Pictured are, from left to right, (first row) Antonio and Philomena with Frank (on lap); (second row) Richard, Jimmy, and Anthony; (third row) Philomena and Pete. (Courtesy of Corrova family.)

THE ORIGINAL TAT RESTAURANT, C. 1950. Jimmy Corrova (left) and brother Richard stand in front of the original TAT Restaurant, which opened in 1929 at 409 West Goodale Street. TAT, a favorite of legendary Ohio State University football coach Woody Hayes, was famous for homemade ravioli, the "Big Pete" Italian sausage (named for Jimmy's father), and the "Poor Boy" sandwich. TAT was named after the Ford tri-motor Transcontinental Air Transport planes that flew over Flytown. (Courtesy of Corrova family.)

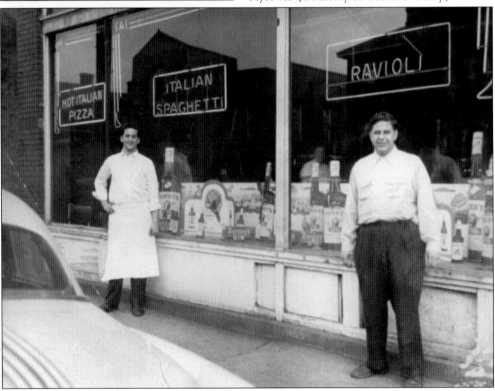

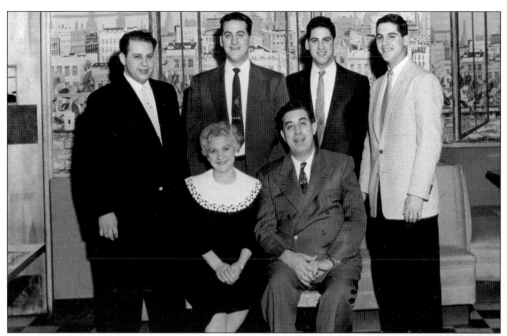

TAT Villa Party Room, c. 1954. After the Flytown neighborhood was mostly razed for freeway construction, the Corrova family opened TAT Villa in a new location at 3280 East Main Street, and the restaurant's party room became a popular gathering place for their loyal Italian clientele. From left to right are (first row) Philomena and Pete Corrova; (second row) Richard, Jimmy, Tony, and Frank. (Courtesy of Corrova family.)

The New TAT Restaurant. Jimmy Corrova and wife, Dolores, would eventually open a new TAT Restaurant, with the help of their children, at 1210 South James Road in Columbus, where the family's signature Italian recipes are still served. Always a generous benefactor of the surrounding community, in 2000, Jimmy was named Catholic Man of the Year as commendation for his years of volunteerism. From left to right are (first row) Dolores and Jimmy Corrova; (second row) Michael Corrova, Michelle Corrova, and Marianne (Corrova) Kirkbride. (Courtesy of Corrova family.)

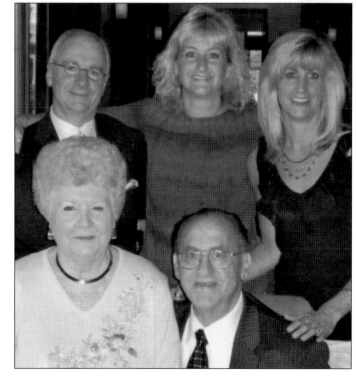

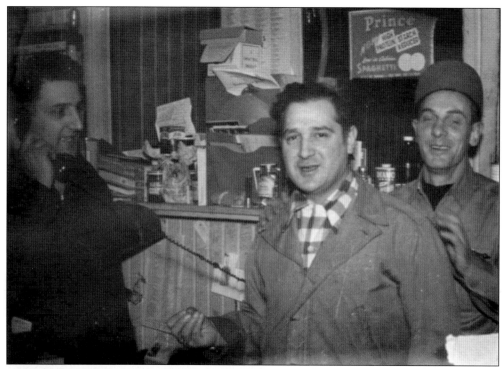

MILITELLO MACARONI COMPANY.
In 1938, Italian immigrant
Gaspar Militello opened
Militello Macaroni Company
at 19 East Naghten Street
in downtown Columbus. He
previously owned G. Militello
Importing in Detroit. In 1969,
the name was changed to
Militello Food Distributors,
and it changed again in 1981 to
Militello Importing Company
when son Vincent took over the
business. The Militello family
imported many Italian foods,
mainly wholesale, and operated
a retail shop selling pasta of
all shapes and sizes. Pictured
above in 1953 are, from left
to right, Gaspar's three sons,
Peter, Dominic, and Vincent.
Pictured at left in 1970 are the
three sons outside Militello
Macaroni Company. (Both,
courtesy of Militello family.)

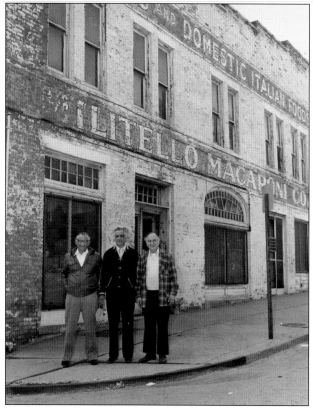

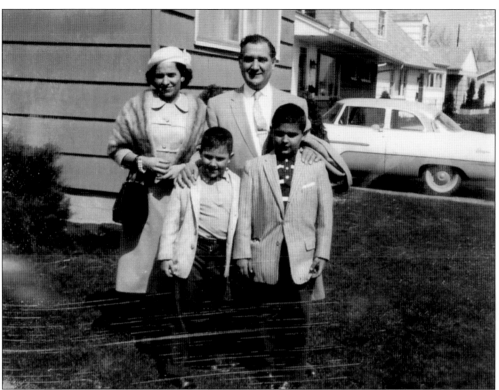

Vincent Militello Family, c. 1959. Vincent Militello took over his father's macaroni company and greatly expanded its importing business. He and his wife, Phyllis, had two sons. From left to right are (first row) Vince and Gasper; (second row) Phyllis and Vincent outside their uncle Pete's house on Enfield Drive in Columbus in 1959. (Courtesy of Militello family.)

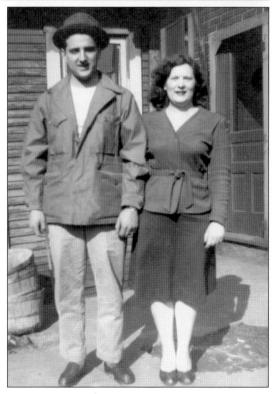

Dominic and Carmela Militello. Gasper Militello's son Dominic (left) and his wife Carmela (Bonora) Militello lived on High Street and eventually moved to Worthington and had three children, Gaspar, Grace, and Dominic. Dominic Sr. worked for the family importing business, and Carmela was employed at the family produce stand at the North Market. (Courtesy of Militello family.)

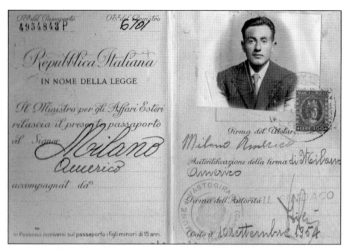

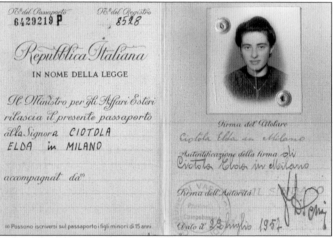

AMERICO AND ELDA (CIOTOLA) MILANO. Americo Milano was born in Cerreto Di Vastogirardi, Italy, in the province of Isernia, Molise, on September 7, 1935. He and his mother arrived in Columbus in December 1954 to join his father in Grandview Heights, several weeks after his wedding to Elda Ciotola. Elda arrived in 1957 and moved in with Americo's family at 1374 Glenn Avenue. Americo and Elda eventually bought their own house a short distance away at 1295 Westwood Avenue and had three children, Lisa, Mary, and Robert. Americo retired from the Marble Cliff Quarry after 43 years. Americo and Elda Ciotola are pictured below on the occasion of their 50th wedding anniversary in 2004 at Our Lady of Victory Catholic Church. (All, courtesy of Ciotola/Milano families.)

GIUSEPPE TIBERI AND RENA SILVESTRI WEDDING, DECEMBER 8, 1959. Giuseppe Tiberi and Rena Silvestri were married in their hometown of Introdacqua, Italy, in the province of L'Aquila, Abruzzo, in 1959. The following year, they moved to Columbus and settled in the Linden neighborhood. Giuseppe was a machine operator for 30 years, and the couple had three children, Patrick, Ida, and Tania. (Courtesy of Tiberi family.)

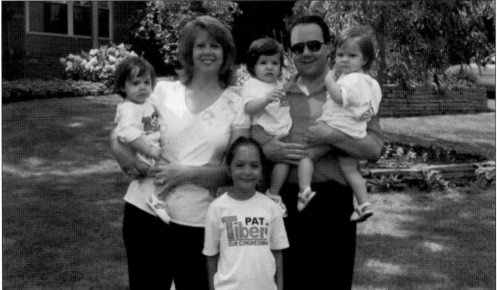

US REPRESENTATIVE PAT TIBERI. US Representative Pat Tiberi is the son of Italian immigrants Giuseppe and Rena Tiberi and maintains strong ties to the Columbus Italian community, having served as chairman of the Columbus Italian Festival. Congressman Tiberi was first elected to serve the people of Ohio's 12th Congressional District in 2000. Congressman Tiberi and wife, Denice, are pictured here with their four daughters, from left to right, Gabriella, Angelina, Daniela, and Christina. (Courtesy of Tiberi family.)

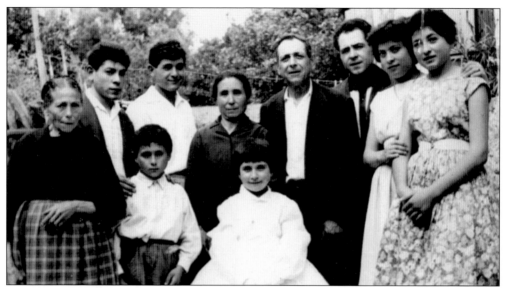

CORDI FAMILY, 1959. This photograph of the Cordi family was taken in Anoia Superiore, Italy, in the province of Reggio Calabria, Calabria, on the eve of their passage to the United States. The Cordi family was sponsored by a relative living on Ontario Street in Columbus, where the family first moved when they arrived. From left to right are (first row) Girolama Longo, Antonio Cordi, and Luciana Cordi; (second row) Giuseppe Cordi, Angelo Cordi, Concetta (Longo) Cordi, Vincenzo Cordi, Michele Cordi, Lina Cordi, and Rosa Marina Cordi. (Courtesy of Auddino family.)

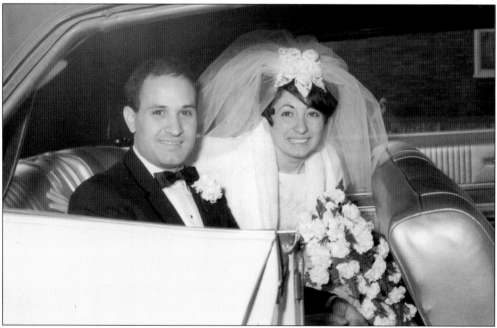

MICHELLE AUDDINO AND ROSA CORDI WEDDING, DECEMBER 30, 1967. Michelle (Michael) Auddino and Rosa Cordi were married in 1967 at St. John the Baptist Italian Catholic Church. Since arriving from Reggio Calabria, they have operated an Italian bakery in Columbus. The Auddinos are perhaps best known for their creative bread sculptures, which were perennially on display at the Columbus Italian Festival. (Courtesy of Auddino family.)

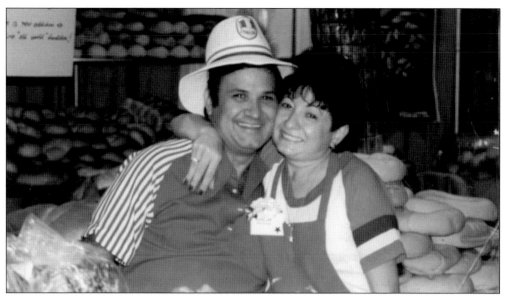

AUDDINO'S ITALIAN BAKERY. Michael and Rosa Auddino opened their first Italian bakery (above) at 2817 Cleveland Avenue, making specialty cakes and breads. In the beginning, they were the only employees and worked seven days a week. They would eventually move into a larger bakery, their current location, (below) at 1490 Clara Avenue. They now employ their three sons, Rosario, Dante, and Marco, along with several other relatives. Auddino's Italian Bakery has become Central Ohio's largest restaurant supplier of high-quality Italian bread, pizza crusts, and rolls, and its retail bakery produces an assortment of fresh baked cannoli, amoretti, and other authentic Italian desserts. (Both, courtesy of Auddino family.)

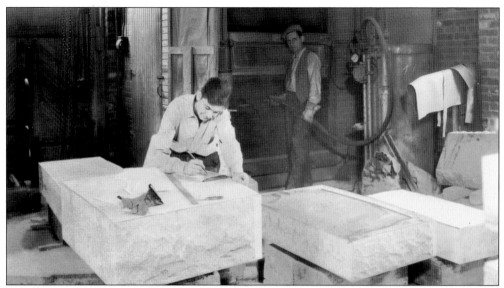

CARMINE TIRRI. Columbus Art Memorial was founded in 1922 by Carmine Tirri (above), who arrived in Columbus from Rapallo, Italy, in the province of Genoa, Luguria, by way of South America. His father, Diodato Tirri, fearing the family would be not allowed to enter the United States as Italian citizens, moved them first to Brazil, where they spent 12 years, and finally arrived in New York in 1907. After serving for his adopted country in World War I, Tirri moved to Ohio, opening Columbus Art Memorial at the corner of Thomas and Glenwood Avenues. (Courtesy of Carmine Menduni.)

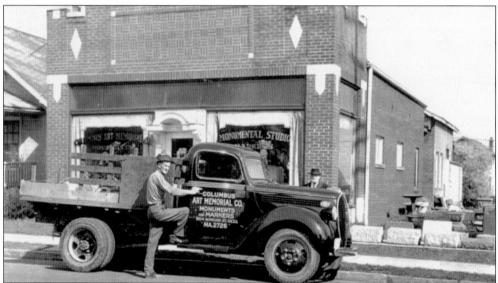

COLUMBUS ART MEMORIAL. In 1932, Columbus Art Memorial moved to 907 West Mound Street. Carmine Tirri (behind truck) is shown with employee Aloisius Igel. After Tirri passed away in 1950, the business was assumed by his niece Christina Menduni, whom he had raised since infancy, and her husband, Louis. When Louis was president of the Sons of Italy, Columbus Art Memorial built the foundation for and erected the Christopher Columbus statue outside of city hall in 1955. Their son, master craftsman Carmine Menduni, now operates the family business at 606 West Broad Street. (Courtesy of Carmine Menduni.)

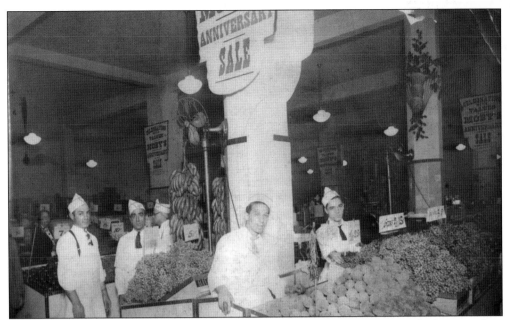

ANTHONY ARENA, 1937. The son of Sicilian immigrants, Anthony Arena worked at a produce stand on the ground floor of Moby's at the corner of Spring and High Streets in downtown Columbus, a department store frequented by Italians. Anthony and his wife, Margaret, had three children, Anthony, Charlotte, and Kathleen. Son Anthony owns Arena Produce on Reynolds Avenue in the St. Clair Avenue area. (Courtesy of Tony Arena.)

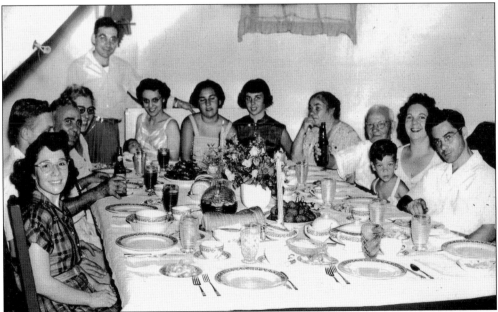

MIKEY ARENA CHRISTENING DINNER, 1951. The Arena family gathers to celebrate Mikey Arena's baptism on August 13, 1951, at their family home at 636 Salisbury Road. Pictured are, from left to right, Antoinette Mead, James Mead, Frank Ferraro, Josephine Ferraro, Mike Arena, Ann Arena (holding Mikey), Eleanor Ferraro, Augustine Ferraro, Agostina Arena, Cosimo Arena, Tony Arena, Margaret Arena, and Anthony Arena. (Courtesy of Tony Arena.)

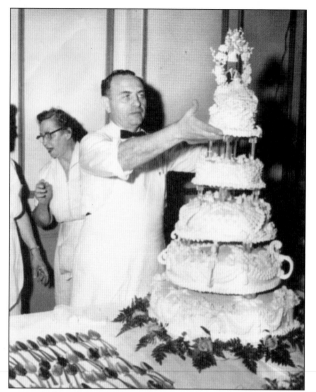

THE "GRAND MARCH MAN." The son of Italian immigrants, Joseph Giantonio was known as the "Grand March Man" because of the Italian wedding cakes he would bake every weekend and serve to brides and grooms at their receptions with much fanfare. Giantonio opened his first bakery in 1927 at the corner of Seymour and Mound Streets in Columbus; the same year, he married Margaret Albanese at St. John the Baptist Italian Catholic Church. They eventually opened a new and much larger Seymour Bakery at 2183 East Livingston Avenue, delivering breads, rolls, cakes, and pies to hotels, restaurants, and schools. (Courtesy of Masdea family.)

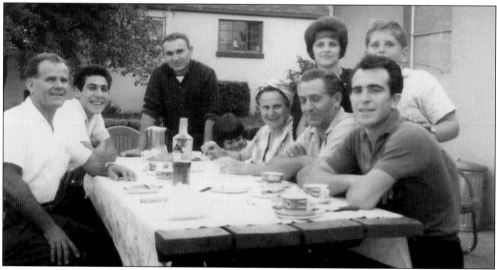

PINGUE FAMILY, 1963. Columbus real estate developer Giuseppe Pingue arrived in Columbus in August 1963 after having spent seven years in Canada with his father and older siblings. The Pingue family is originally from Introdacqua, Italy, in the province of L'Aquila, Abruzzo. This photograph was taken a week after Giuseppe arrived in Ohio to join his in-laws, several relatives on his mother's side, and friends from Introdacqua. Pictured are, from left to right, (sitting) Eugene Ventresca, Joseph Pingue, Paul Pingue, Tina Ventresca (the child), Anna Ventresca, Egidio Ventresca, and Uliano Ventresca; (standing) Linda Ventresca and Anthony Ventresca. (Courtesy of Joe Pingue.)

Three

FRIENDS

Italians have always enjoyed the company of other Italians. In Columbus, the Italian immigrants who arrived here quickly formed their own ethnic subculture. They lived together in several distinctly Italian neighborhoods, St. Clair Avenue, San Margherita, Flytown, Grandview Heights, and in a neighborhood just north of downtown Columbus now called Italian Village. They found jobs together at railroads, quarries, and factories; organized semiprofessional sports teams and traveling bands; patronized the same Italian-owned grocery stores, restaurants, and bars; and attended mass at the same Italian churches. Their social circles revolved around their shared heritage.

But that was then, and things have changed. Many of those large employers and favorite restaurants have been shut down. Columbus's second- and third-generation Italian Americans have left the old neighborhoods favored by the earliest immigrants, spreading to all corners of the city and into suburbia. However, a certain bond still exists, and the Italians of Columbus still come together on a regular basis. The Columbus Italian Festival and St. Margaret of Cortona annual summer festival are the two biggest Italian parties in town. The Guild Athletic Club, the Sons of Italy, Amici D'Oro, La Donna, the Abruzzi Club, the Piave Club, and the Columbus Italian Club are just a few of the active Italian social groups that help keep the Italian friendships strong. On any given night at any one of the many bocce courts in town, one will still see old friends gathering together—a bocce ball in one hand and a glass of vino in the other.

Some things never change.

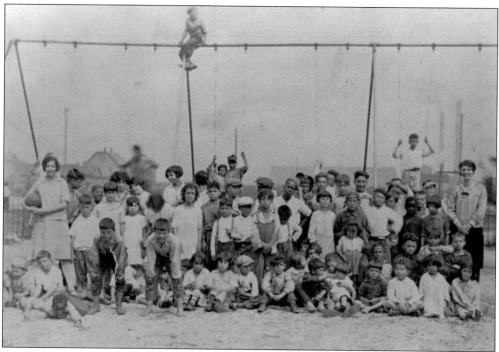

CHILDREN PLAYING OUTSIDE SANTA LUCIA COMMUNITY CENTER. The Santa Lucia Community Center was located at 860 St. Clair Avenue and was the center of Italian social life in Columbus for many decades. It was truly a neighborhood recreation center, sponsoring activities and sports teams for children and adults, both organized, like football, and purely for fun, such as kick-the-can and stickball. (Courtesy of Paul DiPaolo.)

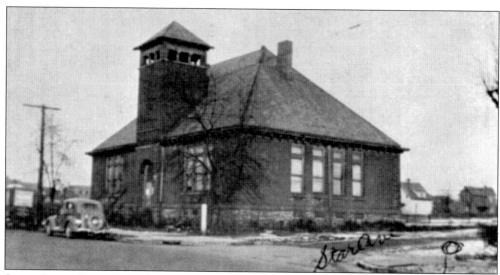

SANTA LUCIA COMMUNITY CENTER. The Societa Fratellanza D'Introdacqua (SFI), a social service organization for Italian immigrants from the town of Introdacqua, in the province of L'Aquila, Abruzzo, purchased the Santa Lucia Community Center in the spring of 1952. The group used the building as its lodge, and it was a popular venue for weddings and other social activities. The building was sold by SFI in the early 1960s and razed in 1980. (Courtesy of Dave Verne.)

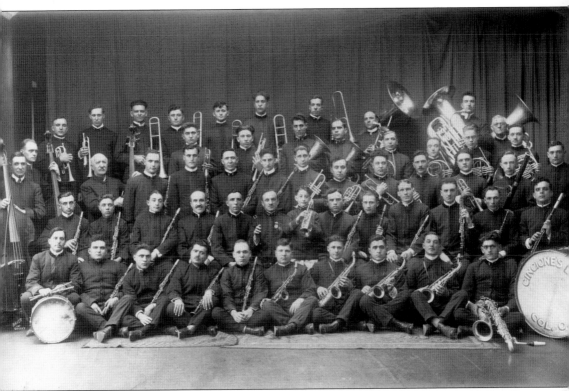

THE CINCIONE FAMILY OF MUSICIANS. Born in Castel di Sangro, Italy, in the province of L'Aquila, Abruzzo, the Cincione family members, brothers Phillip and Alphonse and nephews Henry and Ray, were well known throughout Columbus as talented musicians. Phillip, who had studied at La Scala in Milan before coming to the United States, played for the John Philip Sousa Band and Orchestra at the James Theater on West Broad Street. Alphonse led the American Legion Post No. 1 Band. Both Alphonse and Phillip were members of the Majestic Symphony Orchestra, which played for 124 weeks in 1919–1920. Phillip taught nephew Henry at the age of six to play the trumpet, piano, and violin. He went on to play for Jack Benny, Ginger Rogers, Milton Berle, and Martha Ray. Along with brother Ray, the two appeared regularly at the Gloria Nightclub. His personal dance band, Henry Cincione and the Flytown Brass, also played around Columbus. (Courtesy of Gene D'Angelo.)

VERNE'S CAFÉ. One of the most loved watering holes in the Milo neighborhood, Verne's Café was owned by the Italian immigrant Verne family and located at 762 St. Clair Avenue. The building was a former railroad club with bedrooms on the second floor before it became a bar. Always popular with railroaders, the employees of the nearby Twentieth Street Rail Yard could cash their checks at the bar after they got off of work. (Courtesy of Dave Verne.)

HAMLET STREET, 1930. The streets around St. John the Baptist Italian Catholic Church, Hamlet and Lincoln, were the site of many Italian feast-day celebrations each year, honoring the patron saints of the Italian villages that Columbus's immigrant families left behind. Celebrating in 1930 are, from left to right, (first row) John Berardo, Eddy Susi, and Eugene Pelino; (second row) Lovanio Volpe and Lucian Tiberi. (Courtesy of Pelino/Caminiti families.)

QUEEN ISABELLA, 1929. Lucia Petrella Nance was honored as the first-ever Columbus Day "Queen Isabella" in 1929, for which she was awarded a $50 gold piece. She promptly purchased a car with her winnings. Queen Isabella and her husband King Ferdinand of Spain are credited with having sponsored the voyages of Christopher Columbus. Although celebrated in Columbus beginning in 1929, Columbus Day did not become a federal holiday until April 1934, when Pres. Franklin Delano Roosevelt named October 12 Columbus Day. In a statement, President Roosevelt said, "The promise which Columbus's discovery gave to the world, of a new beginning in the march of human progress, has been in process of fulfillment for four centuries. Our task is now to make strong our conviction that in spite of setbacks that process will go on toward fulfillment." (Courtesy of Pat Nance Brown.)

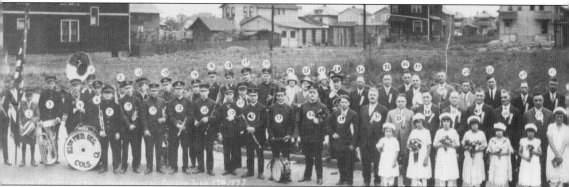

SOCIETA FRATELLANZA D'INTRODACQUA. The Societa Fratellanza D'Introdacqua (SFI) is a social service organization for Italian immigrants from the town of Introdacqua, in the province of L'Aquila, Abruzzo. This photograph was taken at the annual St. Feliciano celebration in 1927 in the empty field on Second Avenue in the St. Clair Avenue neighborhood where many immigrants from Introdacqua settled in Columbus. St. Feliciano is the patron saint of Introdacqua. SFI was founded in Columbus on October 12, 1915, with a main purpose of promoting "fraternal love and mutual assistance in a time of need" among the 75 families from Introdacqua. Families included in

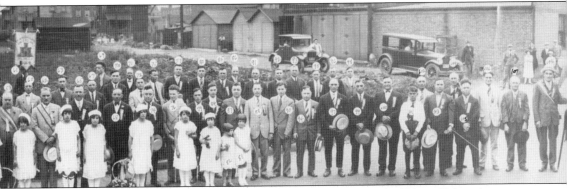

the photograph are: De Cenzo, Fontanarosa, Julian, Faiella, De Angelo, Tiberi, Volpe, Anverse, Montesi, Carifa, Aldini, Ventresca, Berardo, Lotti, Ventresco, D'Andrea, Giammarco, De Cesare, Pellino, Centofanti, Del Signora, Mangini, Ricci, Di Pietro, Verne, De Tunno, Lopresti, Piecoro, Notturniano, Guglielmi, Teatino, Failella, Spinosa, Melchiorre, Cassan, Colangelo, Fracasso, Ofrenzo, Colasante, Signoracci, Sciore, Petruzzi, Blatteri, Bevilacqua, Asmo, Rosati, Bellisari, Vittorio, Finocchi, Susi, and DiPaolo. (Courtesy of the Abruzzi Club.)

GRACE MARTINA. The oldest daughter of Joseph and Catherine Montenaro, Grace Martina, is one of the most well known of all Columbus Italians. She grew up on Glenn Avenue in Grandview Heights, attending the Fifth Avenue School. In a double wedding with her sister Angelina and Joe Roams, Martina married Anthony Angelo Martina on June 5, 1919, at St. John the Baptist Italian Catholic Church. They lived on Oakland Avenue and had six children. She was active in her church and her community, organizing pasta dinner fundraisers, volunteering at St. Vincent's Orphanage, and founding the Mother and Daughter Club. During the 1930s, she started a citizenship school for the many Italians who would not travel downtown for naturalization classes. An empty storeroom was rented to serve as a classroom, and 47 people were part of the first class. In 1980, she was named Woman of the Year by the American-Italian Club, the first woman to ever receive the honor. (Courtesy of the Grandview Heights/Marble Cliff Historical Society.)

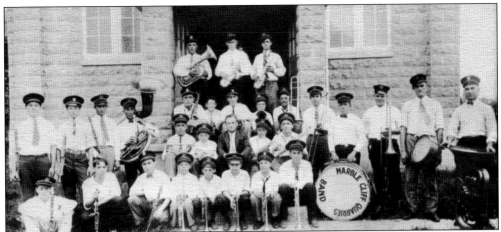

MARBLE CLIFF QUARRIES BAND, 1927. One of many traveling bands popular in Columbus in the 1920s, the Marble Cliff Quarries Band, shown here in front of St. Margaret of Cortona Church, practiced in a shed near the Marble Cliff Quarry and was directed by Alphonse Cincione and his nephew Henry Cincione. Members included boys from the west side and musicians from Cincione's band who played around Columbus. This band played annually in the St. Margaret of Cortona Church festival procession. (Courtesy of Lancia/Shaffer family.)

LEFTY CASANTA, 1930. Frank "Lefty" Casanta introduces the game of baseball to kids in the Milo neighborhood. Casanta, known as Lefty because of his left-handed pitching style, was briefly a professional baseball player with the Detroit Tigers but returned to Columbus to become an umpire and start a citywide little league baseball association, the "Knothole Gang." (Courtesy of Casanta family.)

SCHLEE SCHOOL, C. 1935. Built in 1918 and located at 1046 Jackson Pike, the District No. 8 Schlee School was adjacent to Greenlawn Cemetery and had a large enrollment of Italian immigrant children. It has since been razed. Pictured are Schlee School students of various ages and grades outside the school building around 1935. (Courtesy of Trapasso family.)

TIMKEN ROLLER BEARING COMPANY, C. 1935. The Timken Roller Bearing plant at Interstate 71 and Fifth Avenue in Columbus was built in 1920 and quickly became one of the company's busiest and most successful factories, manufacturing tapered roller bearings for shipment throughout the country. Italians would frequently change their names to get hired at Timken, as it was widely known that the company did not like to hire Italians. Pictured are, from left to right, Beatrice DeCenzo, Margaret Roberts, Mary Roger, Eleanor Fisher, Tommie Gill, and an unidentified friend. (Courtesy of Dave Verne.)

ANTHONY MOTTO, THE GAMBLER.
Well-known professional gambler
and son of Italian immigrants
Anthony Motto is pictured in 1938
in the Flytown neighborhood with
cousin Carmela (Bonora) Militello.
Motto would eventually move
to Las Vegas to pursue his career
ambitions. In the years following
the Great Depression, legalized
gambling was looked upon as a
way to stimulate the economy,
and in 1933, Ohio legalized pari-
mutuel betting, giving rise to
gambling as a legitimate, if not
extremely respected, profession.
(Courtesy of Militello family.)

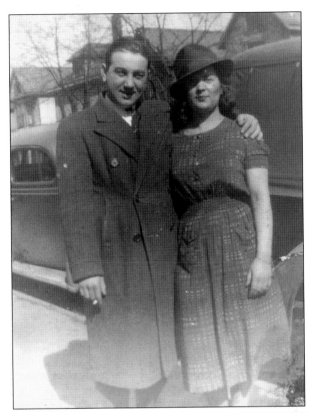

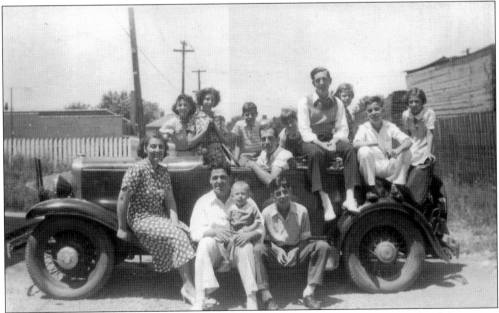

JULY FOURTH IN THE BOTTOMS. This photograph was taken during the July Fourth celebration in 1938 in the low-lying neighborhood immediately west of downtown Columbus, referred to as the Bottoms. The Bottoms, which incorporates the Franklinton neighborhood, got its name because it sits on a floodplain. (Courtesy of Bolognone family.)

D'ANDREA BOYS IN SOAPBOX DERBY CAR. The D'Andrea brothers traveled though the Milo neighborhood in their soapbox derby car. Riding in the car is Edmund, pushing on the left is Antonio, on the right is Danny, and looking on is Teddy. All four boys are the sons of Italian immigrants and played on Santa Lucia Community House athletic teams. (Courtesy of Ventresco/ D'Andrea families.)

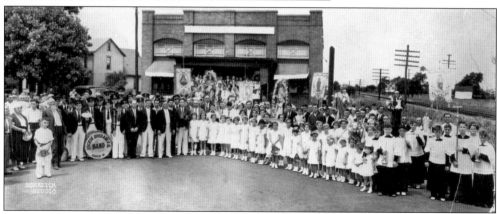

SOCIETA OPERIA F.B. BAND. Societa Operia F.B. Band is pictured in front of the old San Margherita Market at McKinley Avenue and Trabue Road. The band would play for the neighborhood on Sundays and other special occasions. After performing, band members would go door-to-door collecting donations. (Courtesy of St. Margaret of Cortona Church.)

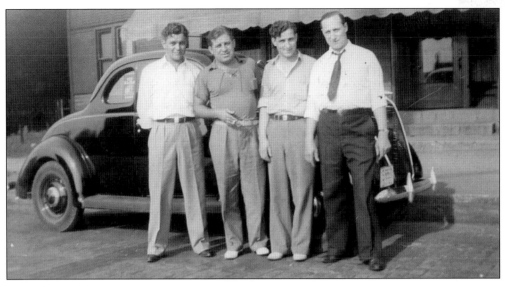

FRIENDS OUTSIDE VERNE'S CAFÉ, C. 1940. Verne's Café was one of the primary social gathering spots for Italians on St. Clair Avenue. Pictured standing between two unidentified friends are, from left to right, Julian "Sword" Verne and James Verne. Other equally well-known hangouts in the Milo neighborhood included Santillis Pool Hall, the Venice Club, and Melchiorre's Grill. (Courtesy of Dave Verne.)

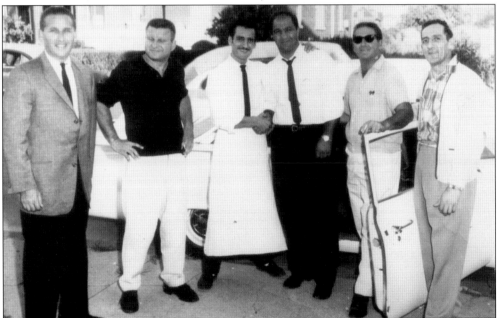

THE BROCKTON BLOCKBUSTER. Famed boxer Rocco Marciano is pictured here visiting his army buddy at the popular Venice Club located at 905 St. Clair Avenue. Marciano's parents emigrated from Italy, and he became the Heavy Weight Champion of the World from September 1952 until his retirement in April 1956. Known as the "Brockton Blockbuster" or the "Rock from Brockton," Marciano was killed in a plane crash in Iowa in 1969. Pictured are, from left to right, Rocco Marciano's bodyguard, Joe Del Teldesco, Moe D'Andrea, Rocco Marciano, Arturo Thomas, and Angelo D'Andrea. (Courtesy of Paul DiPaolo.)

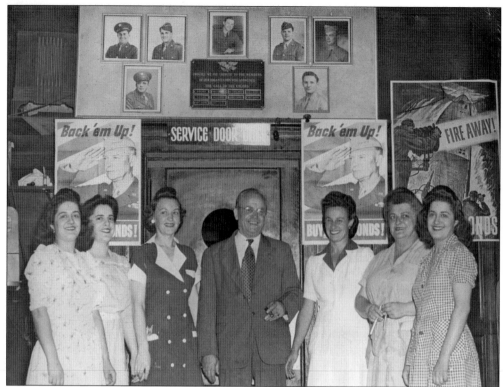

GLORIA NIGHTCLUB HONOR ROLL. Originally named the Gloria Barbecue, the Gloria Nightclub was owned by brothers Sam and Rocco Delewese and their brother-in-law Guy DeVictor. The nightclub featured a dance hall, a roof garden, and an elevated stage. The nightly shows featured singers, dancers, magicians, and comedians. During the war, while the young men were in service, the nightclub had an honor roll for its employees. A plaque hanging above the doorway paid tribute to them. (Courtesy of Grandview Heights/Marble Cliff Historical Society.)

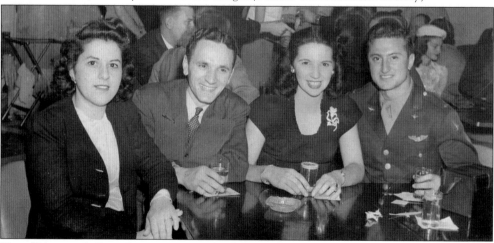

TONY DELEWESE'S CLUB RIVIERA. Located at 360 North Sandusky Street, Tony Delewese's Club Riviera was a popular nightclub that operated from 1938 until 1954. Enjoying a night out at the club are, from left to right, Josephine DiPaolo, Richie DiPaolo, Louise DiPaolo, and Henry DiRienzo. (Courtesy of Paul DiPaolo.)

JIM SANFILLIPO AND FRIENDS, 1945. The grandson of Italian immigrants Salvatore and Vincencina, Jim Sanfillipo Sr. is pictured here with friends in 1945. Jim, fourth from the left, grew up working in his family's produce business and served in the Navy in World War II in the Pacific Theater. After the war, he returned to Columbus to work in the home improvement business. (Courtesy of Jimmy Sanfillipo.)

LINDEN MCKINLEY HIGH SCHOOL STUDENTS, 1945. Members of Linden McKinley High School's first graduating class enjoy a game against Grandview High School. Pictured are, from left to right, James Christian, Felix Merullo, and James Ross on May 18, 1945, at Grandview High School. All three boys were members of McKinley High School's graduating class of 1945. (Courtesy of Felix Merullo.)

GASPAR MILITELLO BIRTHDAY PARTY, 1945. Inside the popular party room at TAT Villa at 3278 East Main Street in Columbus, Gaspar Militello celebrates his birthday. The party was thrown for him by Angelo Bianco, who is holding a cigarette. The guests included Americo Churches, Romeo Sirij, TAT owner Pete Corrova, Louis Masinelli, Tony Montagno, and Dominic Militello. (Courtesy of Corrova family.)

DOUBLE DATE. Pictured here at Tony Delewese's Club Riviera are William (right) and Kathryn Maselli with friends on June 10, 1945. William, the son of Italian immigrants, lived on Third Avenue in the Grandview Heights area and worked for the Italian-owned construction firm Corna and DiCesare buildings roads and churches. William and Kathryn had three sons, William, Michael, and John. (Courtesy of Bill Maselli.)

EASTER SUNDAY, 1946. After Easter Sunday dinner, Pasquale Merullo (left) and Dan Merullo, two of Fortunato and Assunta Merullo's seven children, play baseball in an empty field near their home. The Merullo family, transplants from the Milo neighborhood, lived in the Linden neighborhood at 1780 Windsor Avenue. (Courtesy of Felix Merullo.)

ST. CLAIR AVENUE FOOTBALL TEAM. Fracasso's Grocery takes on Asmo's Grill in this St. Clair Avenue Athletic Club football game. The teams, sponsored by local businesses, were part of the St. Clair Avenue "Big Four" heavyweight league. They practiced on a vacant lot at Cleveland and Fifth Avenues. (Courtesy of Asmo/Jaconetti families.)

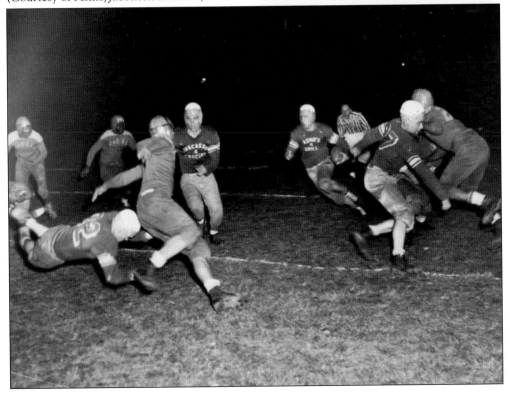

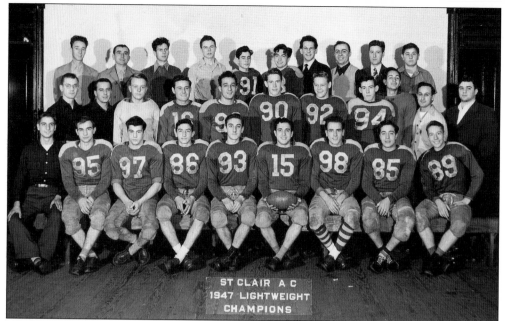

St. Clair Avenue AC 1947 Lightweight Champions. The St. Clair Avenue Athletic Club football team captured the 1947 Lightweight Championship, playing against teams such as the Westside Merchants, Southside Merchants, and Hilltop Merchants. The league consisted of lightweight, middleweight, and heavyweight divisions. (Courtesy of Edmund D'Andrea.)

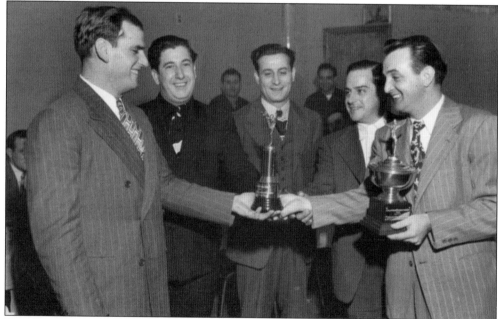

Football Team Banquet. The Santa Lucia Community House was the site of the St. Clair Avenue annual football team awards dinner. Pictured are, from left to right, Pete Melchiorre, Joe Asmo, Julian "Sword" Verne, Donald Fracasso, and Ed Tiberi. Melchiorre, Asmo, Verne, and Fracasso owned businesses that sponsored the St. Clair Avenue "Big Four" teams. Tiberi served as the football coach. (Courtesy of Asmo/Jaconetti families.)

DINNER WITH FRIENDS. Columbus Italians are well known, as are Italians around the world, for socializing largely within their own community. Pictured during a fraternal event in the late 1940s are, from left to right, Art Thomas, Guy Ventresca, Pat Salvatore, Danny Asmo, Armond Asmo, Al Corna, John Corna, Renzo Podova, Eggee Stibelle, Louis Viol, and Joe DiCesare. (Courtesy of Asmo/Jaconetti families.)

20TH-CENTURY FOODS BOWLING LEAGUE SPONSORSHIP, C. 1950. Brothers Tony and Andy DiLoreto, along with Daniel Fiorini and Michael Fiorini, owned and operated 20th-Century Foods at 630 North High Street. The restaurant, which served Italian and American foods, sponsored the local bowling league. Pictured are, from left to right, league secretary Bucky Walters, Tony DiLoreto, Andy DiLoreto, and league president Frank Saley. (Courtesy of Janet DiLoreto Ward.)

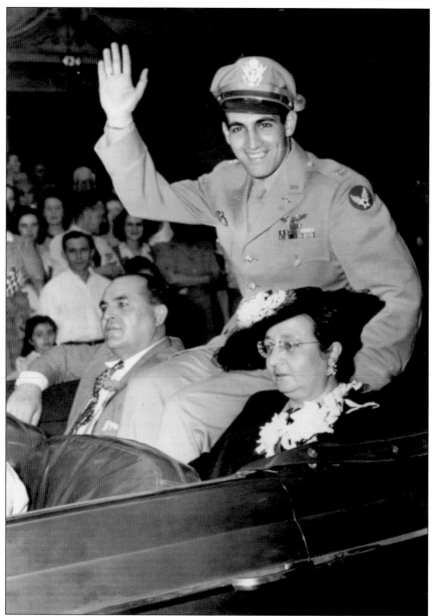

WORLD WAR II VETERAN DON GENTILE. The son of Italian immigrants, Maj. Don Gentile developed a love of flying at an early age. In 1941, he trained to be a fighter pilot with the Royal Canadian Air Force. He was assigned to the British Royal Air Force as a pilot officer and the earned the Distinguished Flying Cross in 1942. Gentile went on to join the US Air Force's 336th Fighter Squadron. By 1944, he had destroyed 27 enemy planes, breaking the record set by Capt. Eddie Rickenbacker in World War I. For his efforts, he received many honors, including two Distinguished Service Crosses, eight Distinguished Flying Crosses, the Silver Star, the Air Medal, the Presidential Unit Citation, and the World War II Victory Medal. A plaque commemorating his accomplishments hangs on the north side of the Ohio Statehouse. He married Isabella Masdea in November 1945, and they had three children, Donald Jr., Joseph, and Pasquale. He was killed in a routine flight January 28, 1951, at the age of 31. (Courtesy of Masdea family.)

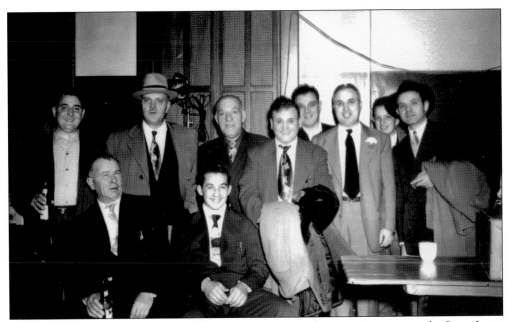

PARTY AT SANTA LUCIA COMMUNITY HOUSE, C. 1950. Friends enjoy an evening at the Santa Lucia Community House. Pictured are, from left to right, (standing) Nello Del Greco, Sam Giammarco, Pat Rosati, Eugene Pelino, John Piecoro, Dom Tiberi, John Piecoro Jr., and Enio Volpe; (seated) John Blateri and Vincent Pelino. (Courtesy of Pelino/Caminiti families.)

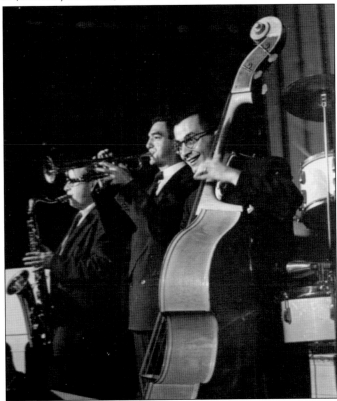

THE GENE D'ANGELO BAND, C. 1951. The Gene D'Angelo Band performed nightly at the Riviera Supper Club on Sandusky Street. D'Angelo played bass and made a living as a professional musician for many years before becoming the general manager of a Columbus television station. He is still active in the Italian community, having been inducted in 2010 into the City of Columbus Hall of Fame and serving as the grand marshal of the Columbus Day parade. (Courtesy of Gene D'Angelo.)

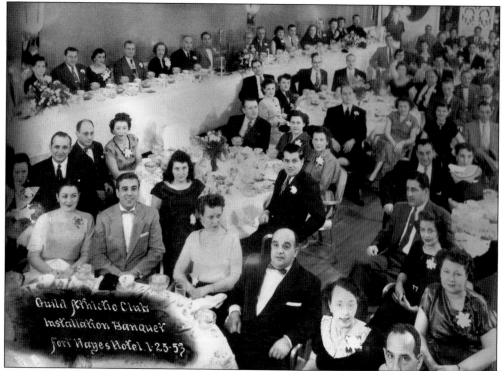

GUILD ATHLETIC CLUB INSTALLATION BANQUET, 1953. The Guild Athletic Club (GAC), a social and amateur athletic organization, of which many Italians are members, held its annual installation banquet at the Fort Hayes Hotel on January 25, 1953. The group still meets weekly and includes many prominent local Italian businessmen. (Courtesy of the Guild Athletic Club.)

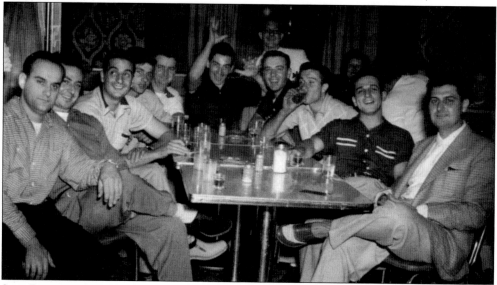

STAG PARTY, 1953. Louis Viol is the guest of honor at his stag party at the Club Riviera on Sandusky Street. Pictured are, from left to right, Louis Viol, Guy Julian, Edmund D'Andrea, Johnny Santa Rosa, Charles Timlin, Tony Bracaloni, Hugo Della Flora, Frank Garbuglio, Joe Capparuccini, and Carl Brusadine. (Courtesy of Edmund D'Andrea.)

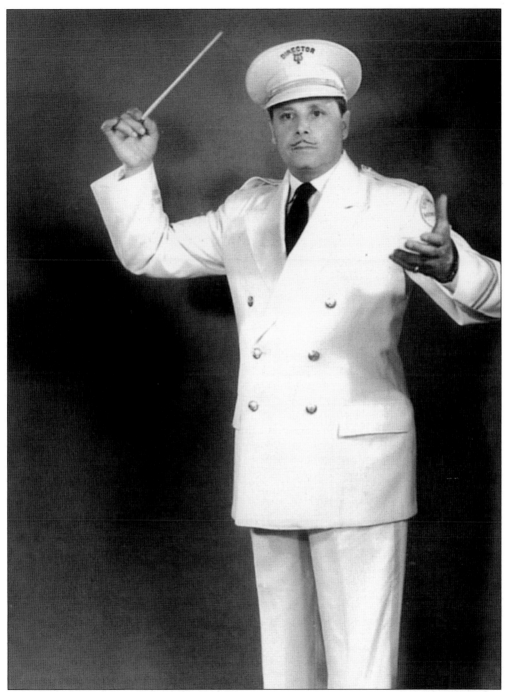

JOSEPH MASDEA. Born in Filadelfia, Italy, in the province of Vibo Valentia, Calabria, in 1896, Joseph Masdea settled in Columbus in 1928. He played trumpet with various bands in the city, including Alphonse Cincione's Franklin Post No. 1 Legion Band. He eventually started the Masdea Concert Band; in 1953, Columbus City Council named the band the Columbus Municipal Band, and it played for all official functions in the city. The band played at the dedication of the Christopher Columbus statue on West Broad Street in 1957. (Courtesy of Masdea family.)

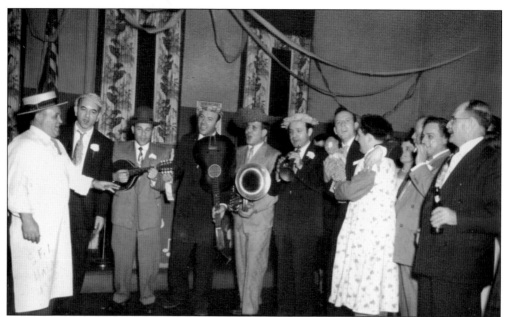

ABRUZZI CLUB PARTY, 1955. Members of the Abruzzi Club celebrate at SFI Hall in 1955. Pictured are, from left to right, Eugene Pelino, Elio Pelino, John Bevilacqua, Pat Giammarco, Enio Volpe, Danny Asmo, Nello Del Greco, Virginia Blateri, John Blateri, Don Fracasso, and Jerry Roberts. (Courtesy of Pelino/Caminiti families.)

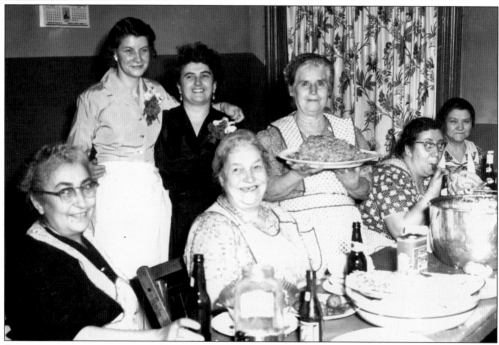

GUILIANOVA CLUB BANQUET. The ladies of the Guilianova Club enjoy a pasta dinner at Santa Lucia Community House. Guilianova, Italy, is a coastal town in the province of Teramo, Abruzzo. From left to right are (first row) Rosa Panico, Maria Bianco, Jenny Galilei, and Rose DiCesare; (second row) Anna Clare, Edith D'Andrea, and Diamond Asmo. (Courtesy of Asmo/Jaconetti families.)

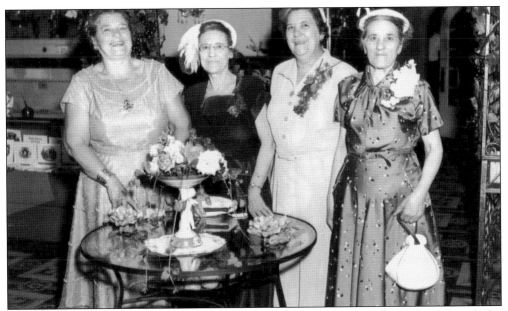

GUALTIERI SISTERS AT PRESUTTI'S VILLA, 1955. The Gualtieri sisters enjoy a night at the popular Presutti's Villa in 1955. Pictured are, from left to right, owner Rosa "Mama" Presutti, Angelina Gualtieri Melfi, Connie Gualtieri Tarantelli, and Anna Gualtieri Petrella. Angelina was a homemaker who dabbled in politics, while Connie operated Connie's Grill on Perry Street, and Anna owned Bell's Grocery on Michigan Avenue. (Courtesy of Pat Nance Brown.)

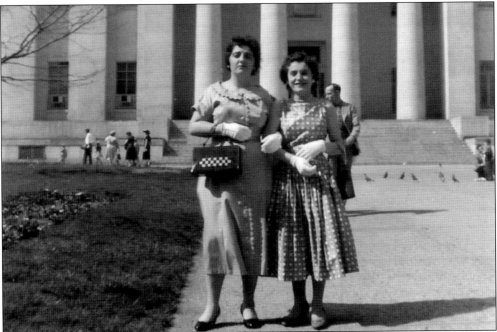

ELEANORE SUSI AND BAMBINA DIRIENZO. Eleanore Susi (left) and Bambina DiRienzo are photographed in front of the Ohio Statehouse in 1956. After mass at St. Peter's Church, the two friends would often take the bus from Fifth Avenue downtown to enjoy ice cream. (Courtesy of Bambina Tiberi-Ventresca.)

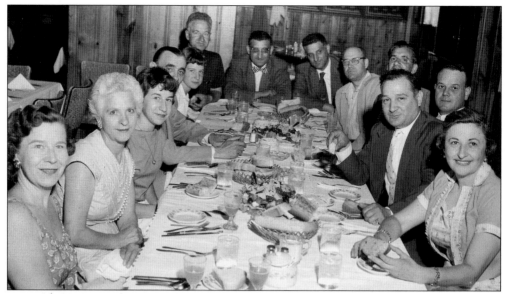

MAYOR M.E. SENSENBRENNER AT TAT VILLA. TAT Villa was a popular dining spot for everyone in the city, including Columbus mayor Maynard Edward "Jack" Sensenbrenner. Sensenbrenner served the people of Columbus from 1954 to 1960 and then again from 1964 to 1972. The mayor, fourth from left, is shown here enjoying dinner with friends. (Courtesy of Corrova family.)

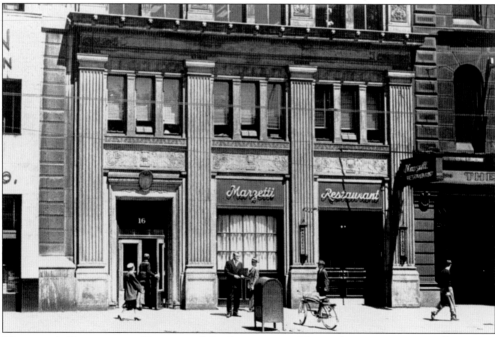

MARZETTI'S RESTAURANT. For most of the last century, Marzetti's restaurant was a favorite in Columbus opened by Italian immigrants Teresa and Joseph Marzetti in 1896. Their business philosophy was simple, "we will start a new place and serve good food. At a profit if we can, at a loss if we must, but we will serve good food." After Teresa Marzetti's death in 1972, the restaurant closed, but a factory making Marzetti-brand salad dressings has made this Columbus pioneer a household name. (Courtesy of the Marzetti Company.)

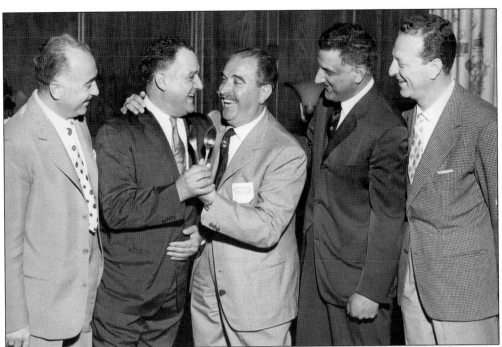

CHEF VINCENT MILITELLO.
Vincent Militello (second from left) meets with "Chef Alfredo," a famous chef who was visiting Columbus. Militello was a well-known chef in his own right in Columbus, operating Militello Macaroni Company at 19 East Naghten Street and cooking at the Guild Athletic Club (GAC) for more than 40 years. He would cook huge pasta dinners every Friday afternoon for local police officers, friends, and city employees. He was famous for his homemade clam sauce and baked Italian chicken. He died in 1998 at the age of 85. The kitchen at the GAC has been renamed the "Vince Militello Kitchen." (Both, courtesy of Militello family.)

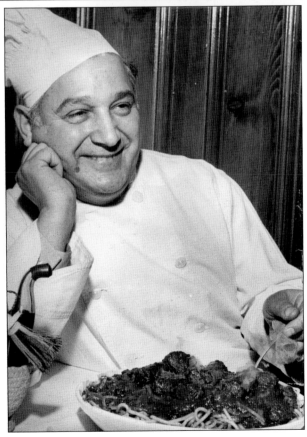

MIKE PEPPE
1932

OHIO STATE SWIMMING COACH MIKE PEPPE. Legendary Ohio State University swimming coach Mike Peppe coached more Olympic divers than any other man. Peppe, the son of Italian immigrants from Salerno, graduated from Ohio State University in 1927 and received a master's degree from Columbia University in 1928. He returned to Ohio State in 1931 when he became the university's first swimming coach and the only head swimming coach until his retirement in 1962. During those 33 years, Peppe and the Buckeyes won 33 major championships, 12 Big Ten Championships, 11 NCAA Championships, and 10 NAAU Championships. In dual meets, Ohio State won 173 and lost 37. Peppe's teams went undefeated in 12 different seasons. He was the Olympic coach for the United States in 1948 and 1952, earning five gold medals. He coached divers and swimmers to 24 Olympic berths. (Courtesy of the Ohio State University.)

AMERICAN ITALIAN GOLF ASSOCIATION.
The American Italian Golf Association was
formed after World War II by a group of Italian
American friends who gathered on Sundays
to play golf. They held their first tournament,
organized by Pat Guidi, at Indian Spring Golf
Course on Columbus Day, October 12, 1947.
The group eventually purchased a 33-acre
plot of land on Wilson Road for their own
clubhouse and, in 1970, moved to their current
home, the Riviera Country Club in suburban
Columbus. (Courtesy of Bill Maselli.)

JOE SCARPELLO. Wrestler Joe Scarpello stands
in front of Militello Macaroni Company at 19
East Naghten Street. Scarpello, born January
16, 1923, was a well-known wrestler who
trained in Columbus with Al Haft. He was an
alternate on the 1948 Olympic team and would
soon thereafter turn professional, embarking
on a 25-year career. Wrestling mainly for the
American Wrestling Association, Scarpello was
known throughout the Midwest, the South, and
in Japan. (Courtesy of the Militello family.)

CATHOLIC MAN OF THE YEAR. Restaurateur Dante Asmo was named Catholic Man of the Year in 1960. Asmo owned several restaurants in the St. Clair Avenue area, including Asmo's Grill, which became Diamond Grill; the Horseshoe Grill; and Yolanda's restaurant. Asmo sponsored local football teams, visited the sick, volunteered at St. John the Baptist Italian Catholic Church, and launched a program to help recently released prisoners become reintroduced to life on the outside. (Courtesy of Asmo/Jaconetti families.)

St. Margaret of Cortona Annual Festival, 1972. Parishioners of St. Margaret of Cortona Church cook pizzelles, a popular Italian cookie, in the parish hall for the church's Italian festival in 1972. The festival is held annually the last weekend of July. Pictured are, from left to right, Helen Blackburn, Dora Rees, Marge Donovan, Anna Castorano, and Fr. James Kulp. (Courtesy of St. Margaret of Cortona Church.)

The Burning of the Dum-Dum Lady. This annual tradition among the members of the Abruzzi Club in Columbus traces its roots to their hometown in L'Aquila, Italy. The dance of the Bandasima was first held at the end of the Feast of St. Feliciano, the patron saint of Introdacqua. The Bandasima is an elaborate costume made of wood and colored paper, which was fitted onto a dancer who paraded through the streets and piazzas. The costume was then set on fire while the dancer twirled underneath the flames. The *Bandasima*, or "dum-dum" lady, is said to be inspired by an ancient pagan sacrifice. In the name of safety, a doll is burned in more recent observances. (Courtesy of Rita Kreuzer.)

BOCCE AT THE ABRUZZI CLUB. The September 3, 1978, cover story on the *Columbus Dispatch Sunday Magazine* profiled the bocce players at the Abruzzi Club off of Cleveland Avenue. The Abruzzi Club is one of several active Italian fraternal organizations; however, it is one of just a few that allows both men and women. There are both outdoor and indoor bocce courts on the Abruzzi Club's heavily wooded and well-hidden property in suburban Columbus. Pictured are, from left to right, Egisto Del Greco, Nello Del Greco, Dan Borghese, Joe Tiberi, Danny LaPenna, and Enio Volpe. (Courtesy of Gene Posani.)

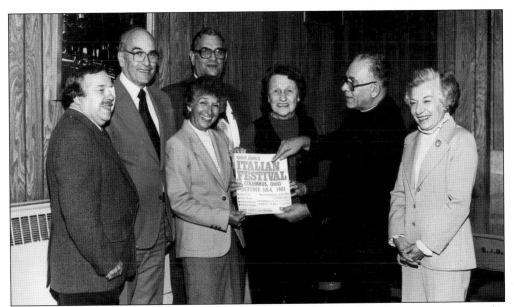

COLUMBUS ITALIAN FESTIVAL, 1981. The Columbus Italian Festival, founded in 1980 on the principles of "faith, family, and friends" by Fr. Casto Marrapese, was first held in the Lausche Building at the Ohio State Fairgrounds before being moved to Italian Village. Pictured holding an early festival program are, from left to right, Vic Pisani, Frank Oliverio, Pat Denardo, Dora Gelonese, Marie Collier, Fr. Casto Marrapese, and Tillie Salvatore. (Courtesy of St. John the Baptist Italian Catholic Church.)

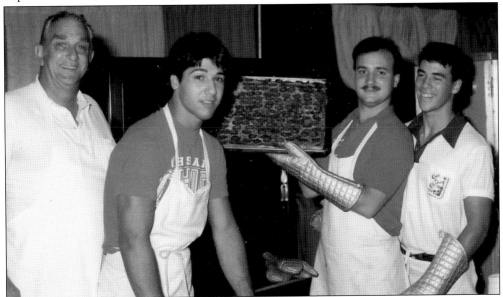

CARFAGNA'S OLDE WORLD PIZZERIA BOOTH, 1988. The Carfagna family has operated a popular Italian grocery store on East Dublin Granville Road in Columbus since 1937. Longtime benefactors of St. John the Baptist Italian Catholic Church and the Columbus Italian Festival, Carfagna family members have been serving Italian fare at the festival since its inception. Sam Carfagna, third from left, is pictured at the 1988 festival with his pizza-making crew. (Courtesy of St. John the Baptist Italian Catholic Church.)

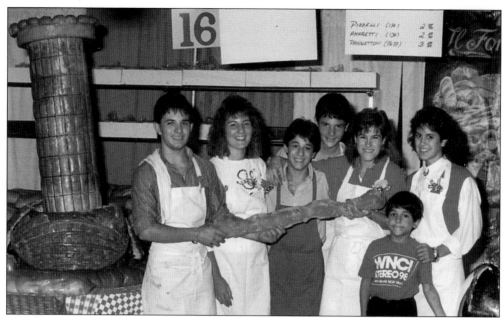

AUDDINO'S FAMOUS BREAD SCULPTURES, 1988. Auddino's Italian Bakery and their unique bread sculptures were permanent fixtures at the Columbus Italian Festival for many years. Pictured next to their Leaning Tower of Pisa bread sculpture are, from left to right, Rosario Auddino, Brenda Milano, Dante Auddino, Cory Huston, Tara Mehann, Tricia Bianconi, and Marco Auddino. (Courtesy of St. John the Baptist Italian Catholic Church.)

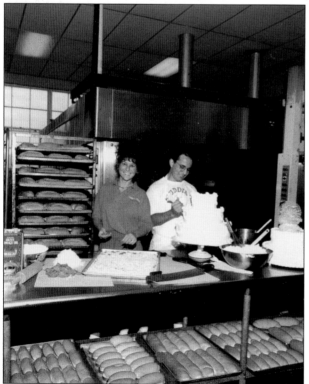

ROSARIO AUDDINO AND TAURA CAPUANO. Rosario Auddino and Taura Capuano volunteer at the Columbus Italian Festival, which had been moved to the multipurpose building at the Ohio State Fairgrounds. The couple was married in 1994 after meeting at the festival in 1980. Rosario's family owns Auddino's Italian Bakery in Columbus. Taura's family owns and operates Cappy's Pizza in London, Ohio. The couple has five children. (Courtesy of Auddino family.)

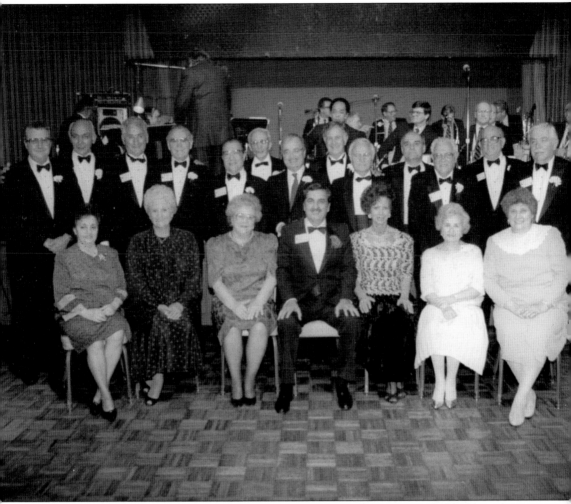

St. Clair Avenue Reunion, 1987. Since 1981, former St. Clair Avenue residents have been gathering annually to reminisce about the old neighborhood. The group is pictured here at their 1987 reunion at Villa Milano Conference and Banquet Facility in Columbus. Prior to this reunion, St. Clair Avenue committee members returned to the Milo neighborhood and went house by house to recall who lived where. A special video tribute, entitled "The Way We Were" and narrated by Fr. Casto Marrapese, was shown. As Father Marrapese described the Italian neighborhood that has bonded them all these years, he said there were enriched in so many ways by having lived there, despite their poverty. Marrapese said, "They were not poor. They simply had no money. Poor is a state of mind." (Courtesy of Edmond D'Andrea.)

MARCO AUDDINO, 1985. Marco Auddino, the youngest son of Michael and Rosa Auddino, hides in a large bread bowl at the Columbus Italian Festival at the Ohio State Fairgrounds. Auddino's Italian Bakery, currently located at 1490 Clara Avenue, operates a wholesale bakery, producing Italian-style bread products for restaurants, pizza shops, and grocery stores throughout Central Ohio. (Courtesy of St. John the Baptist Italian Catholic Church.)

RAY MASSA AND THE EURORHYTHMS. One of the most sought after musical variety acts, Ray Massa's Eurorhythms has entertained audiences from coast to coast since 1982. Members have been acclaimed for their ability to captivate both younger audiences, while thrilling established fans of Italian and swing music. The band performs traditional Italian songs with a high energy pop sound. Ray Massa was born and raised in Bellaire, Ohio, to Italian immigrants from the Campania region of Italy. (Courtesy of Ray Massa.)

THE SAN GIOVANNI DANCERS. A group of lively performers, the San Giovanni Dancers, entertain audiences with dances like the Tarantella Siciliana throughout Ohio at festivals, weddings, fundraisers, and other celebrations. With the support of St. John the Baptist Italian Catholic Church and Fr. William A. Metzger, the San Giovanni Dancers Italian folk-dancing group performed for the first time in May 2000. Spanning several generations, the group includes high school and college students, parents and their young children, and working adults and retirees. The group was founded by Claudio and Leslie Pasian. (Courtesy of Claudio Pasian.)

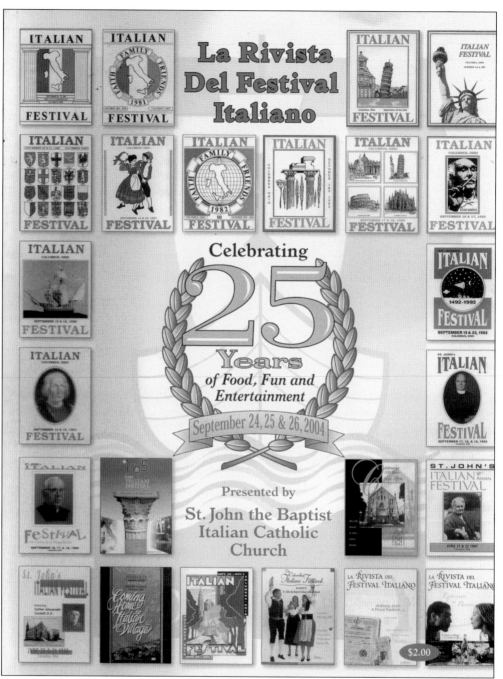

COLUMBUS ITALIAN FESTIVAL 25TH ANNIVERSARY PROGRAM. The weekend of September 24, 2004, marked the 25th anniversary of the Columbus Italian Festival. The annual festival was originally held at the Ohio State Fairgrounds but moved to the grounds of St. John the Baptist Italian Catholic Church in 1998. A special commemorative program featuring all 25 program designs from over the years and was sold for $2. (Courtesy of Clara Zari.)

COLUMBUS DAY PARADE 1991. Members of the Columbus Italian Club and their families participate in the Columbus Day parade in 1991. Pictured are, from left to right, Adrienne Caruso, Rita Flichia, club president Joe Caruso, club vice-president Gus Flichia, Alex Caruso, and Carol Caruso. (Courtesy of the Columbus Italian Club.)

CIC REVERSE RAFFLE. The seventh annual Columbus Italian Club (CIC) Reverse Raffle was held at Villa Milano Banquet and Conference Center August 28, 1993. Pictured are, from left to right, Anthony Arena, Anthony Capuano, Robert DiBeneditto, Gus Flichia, Charlie Vitelli, Bruce Massa, Jimmy Sanfillipo, Joseph Vittorio, Nick Colasante, Bob Behal, Paul DiPaolo, James Luckino, and Tom Sabatino. The club hosts the "reverse raffle" or CIC prom every August. Top raffle prizes include $10,000 and an all-expenses-paid trip to Italy. (Courtesy of the Columbus Italian Club.)

COLUMBUS ITALIAN CLUB. The Columbus Italian Club was founded in 1978 by a group of local Italian businessmen to encourage and support their fellow members through fellowship and networking, while developing social opportunities to celebrate their Italian heritage. Each year, the CIC awards college scholarships to a number of high school students of Italian descent, and in 2010, it attempted to break the Guinness Book of World Record for the world's largest meatball. At its clubhouse (above) on West Third Avenue in Grandview, the CIC houses three lighted bocce courts for its summer and fall bocce leagues, held Monday nights from Memorial Day to Thanksgiving. The three men at left closest to the camera are, from left to right, Tom Andres, Mike Taliercio, and Gus Flichia. The rest are unidentified. (Both, courtesy of the Columbus Italian Club.)

GUILD ATHLETIC CLUB. Sostene Codispoti, the 2010 president of the Guild Athletic Club (GAC), serves up pasta and meatballs to Landa Brunetta at a Sunday afternoon pasta dinner fundraiser. Harold Ballard stands in the background. The club was founded in 1930 as a social service and amateur athletic association. The land to build the clubhouse was purchased in 1956 and is located at 1114 Ridge Street in Columbus. It includes a formal dining area, bar, and several outdoor bocce courts. The Piave Club, another Italian service organization, also meets at the GAC facility. (Both, courtesy of Dominianni family.)

PIAVE CLUB. Founded by Italian American men in 1919 as a social and service organization of professional men in Columbus, the Piave Club is named after a river located in northeast Italy. The river was the site of a historic battle in World War I where the Italian army prevailed against the Axis Austro-Hungarian army as it tried to invade northern Italy. The club was instrumental in establishing the Columbus Day celebration held in Central Ohio from the 1950s to 2005. With the help of the Columbus Italian Festival, the club has re-established the Columbus Day celebration, sponsoring the festival's Columbus Italian Parade. The Piave Club has received several civic awards for its charitable work in the community. (Both, courtesy of the Piave Club.)

SANTA MARIA REPLICA. In 1492, Christopher Columbus set sail in search of a new world on a 98-foot wooden *nao* (cargo ship), the *Santa Maria*. In 1992, on the 500th anniversary of his trans-Atlantic journey, this replica of the *Santa Maria* was commissioned on the Scioto River in downtown Columbus. She was built by Scarano Boatbuilding, Inc., of Albany, New York, and is open for tours and overnight stays. (Courtesy of Amy Lutz.)

COLUMBUS ITALIAN FESTIVAL. The Columbus Italian Festival attracts tens of thousands each Columbus Day weekend to historic Italian Village and the grounds of St. John the Baptist Italian Catholic Church. The festival includes both a traditional and contemporary stage featuring top national talent, a wide assortment of Italian delicacies, a full church-sponsored pasta dinner, Italian dancers, a bocce tournament, a children's area, and a festival marketplace. (Courtesy of St. John the Baptist Italian Catholic Church.)

COLUMBUS ITALIAN FESTIVAL CORK-OFF, 2010. The 31st annual Columbus Italian Festival started on October 8, 2010, with the annual "cork-off." Pictured are, from left to right, St. John the Baptist Italian Catholic Church pastor and festival chief executive officer Fr. William A. Metzger, festival cochairmen John Contino and Andy Dominianni, and Columbus mayor Michael Coleman. (Courtesy of Dominianni family.)

ZONA BAMBINI. Will Dominianni, age three, enjoys time in the Zona Bambini at the Columbus Italian Festival. The *Zona Bambini* (children's area) features Mackie the Clown, rides, inflatable bounce houses, and face painting, as well as Italian-themed arts and crafts, such as make-your-own Mr. Meatball and design-your-own pasta necklaces. (Courtesy of Dominianni family.)

123

STELLA CHAPIN. Known as "Mama Stella" and the "Empress of Pastry," Stella Chapin was a culinary icon in Columbus for many years. She was "discovered" at an early age by the undisputed queen of Italian cuisine. When Chapin was 15 and working at a grocery store, a customer named Rosina Presutti, cofounder of Presutti's Villa, took notice of her. "Mama Presutti," as she was called, said to Chapin, "What a beautiful little girl you are. Why don't you come to work for me?" She did, and the rest, as they say, is history. Later in her career, Chapin struck out on her own, taking an old rambling house on High Street and turning it into a landmark. She operated her own restaurant, Casa Di Pasta, there for 32 years and later was drafted out of retirement to take over the kitchen at Vittoria's Ristorante in Powell. It was often said that Stella served no customers—she only served friends. She died at the age of 85 in 2010. (Courtesy of St. John the Baptist Italian Catholic Church.)

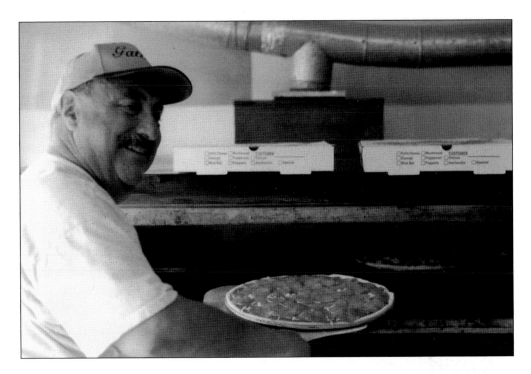

GATTO'S PIZZA. Joe Gatto II takes a pizza out of the oven at his family's pizza shop. Gatto's Pizza was one of the earliest pizza places in Columbus. It has been located in the same building in Clintonville since it opened in 1952. It is now owned and operated by second- and third-generation family members. (Both, courtesy of Gatto family.)

WORLD'S LARGEST MEATBALL ATTEMPT. The Columbus Italian Club (CIC) attempted to break the Guinness world record for the largest meatball at 2010 Columbus Italian Festival. Proceeds from the 800-pound meatball attempt benefited the Columbus Italian Club's Education Assistance Scholarship Program, which awards scholarships to deserving Central Ohio high school students of Italian descent. Ingredients in the meatball (below) included 1,100 pounds of ground sirloin, onion, and dried spices. After cooking for two days, the 655-pound meatball fell short of the record by 94 pounds. (Both, courtesy of the Columbus Italian Club.)

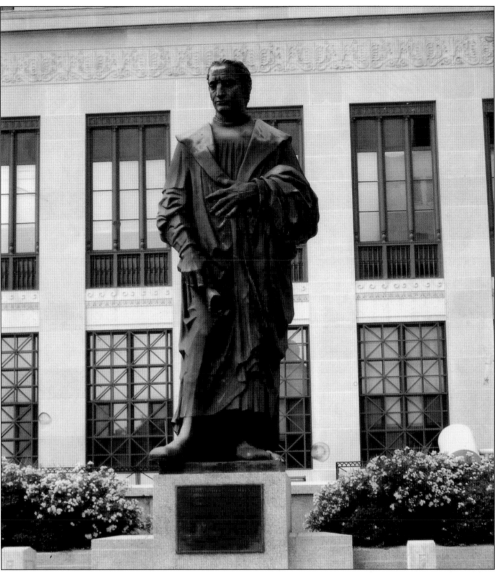

CHRISTOPHER COLUMBUS STATUE. The famous Italian explorer for whom Columbus is named still keeps watch over the city from a lofty perch along West Broad Street outside Columbus City Hall. In commemoration of its new sister city relationship, Columbus received the bronze statue of Christopher Columbus as a gift from the people of Genoa, Italy, in 1955. On August 6, 1955, the following decree was presented to the people of Columbus and the Sons of Italy from the Honorable Manilo Brosio, Italian ambassador to the United States: "Allow me to compliment you and all the members of the committee who have been so successful in organizing this new manifestation of Italian-American friendship. Accept my best wishes for the forthcoming celebration for the dedication of the statue of Christopher Columbus in your home city." The piece itself was sculpted by artist Edoardo Alfieri. It remains a true landmark downtown. (Courtesy of Amy Lutz.)

www.arcadiapublishing.com

Discover books about the town where you grew up, the cities where your friends and families live, the town where your parents met, or even that retirement spot you've been dreaming about. Our Web site provides history lovers with exclusive deals, advanced notification about new titles, e-mail alerts of author events, and much more.

MADE IN THE

Arcadia Publishing, the leading local history publisher in the United States, is committed to making history accessible and meaningful through publishing books that celebrate and preserve the heritage of America's people and places. Consistent with our mission to preserve history on a local level, this book was printed in South Carolina on American-made paper and manufactured entirely in the United States.

This book carries the accredited Forest Stewardship Council (FSC) label and is printed on 100 percent FSC-certified paper. Products carrying the FSC label are independently certified to assure consumers that they come from forests that are managed to meet the social, economic, and ecological needs of present and future generations.

FSC
Mixed Sources
Product group from well-managed
forests and other controlled sources

Cert no. SW-COC-001530
www.fsc.org
© 1996 Forest Stewardship Council

Find Your Place in History.